SURREAL

Art Reflections

L F Peterson Ph.D.
Peterson Art Gallery
Volume 2
Copyright © 2019

Welcome to the second edition of my creative art series. As a cognitive psychologist, I am aware of the contributions of gestalt to the field of art creation and interpretation. Art and psychology encourage creative, novel synthesis. Perceptions are a flux of continually moving conscious and unconscious cognitions forming Multi Factorial Apperceptions. Artists capture subjective experience and observers form new experiences. The greater the ambiguity, the greater the opportunity for aesthetic growth and cognitive change. My art is both an expression of creativity and a mechanism for ambiguity to value-maximize opportunities for interaction and novel interpretation.

Where scientists seek to narrow interpretation, artists seek to employ the Look, See, and Think approach maximize interpretations of their work. Gestalt psychology illustrates how minds interpret similarity, proximity, symmetry, and figure ground to form order out of chaos. Color, shape, distance and density stimulate memories and complex ideas. Ambiguity demands new perspectives until Eureka, or cognitive consistency is achieved.

The following paintings in volume 1 were created over a two year period in 2017 through 2018. I employ a small brush under magnification to create my art renderings. I trust my paintings will stimulate new emotional and intellectual awareness and understanding. I will be publishing over 1200 paintings in the near future and trust you will follow my creative efforts through the various volumes.

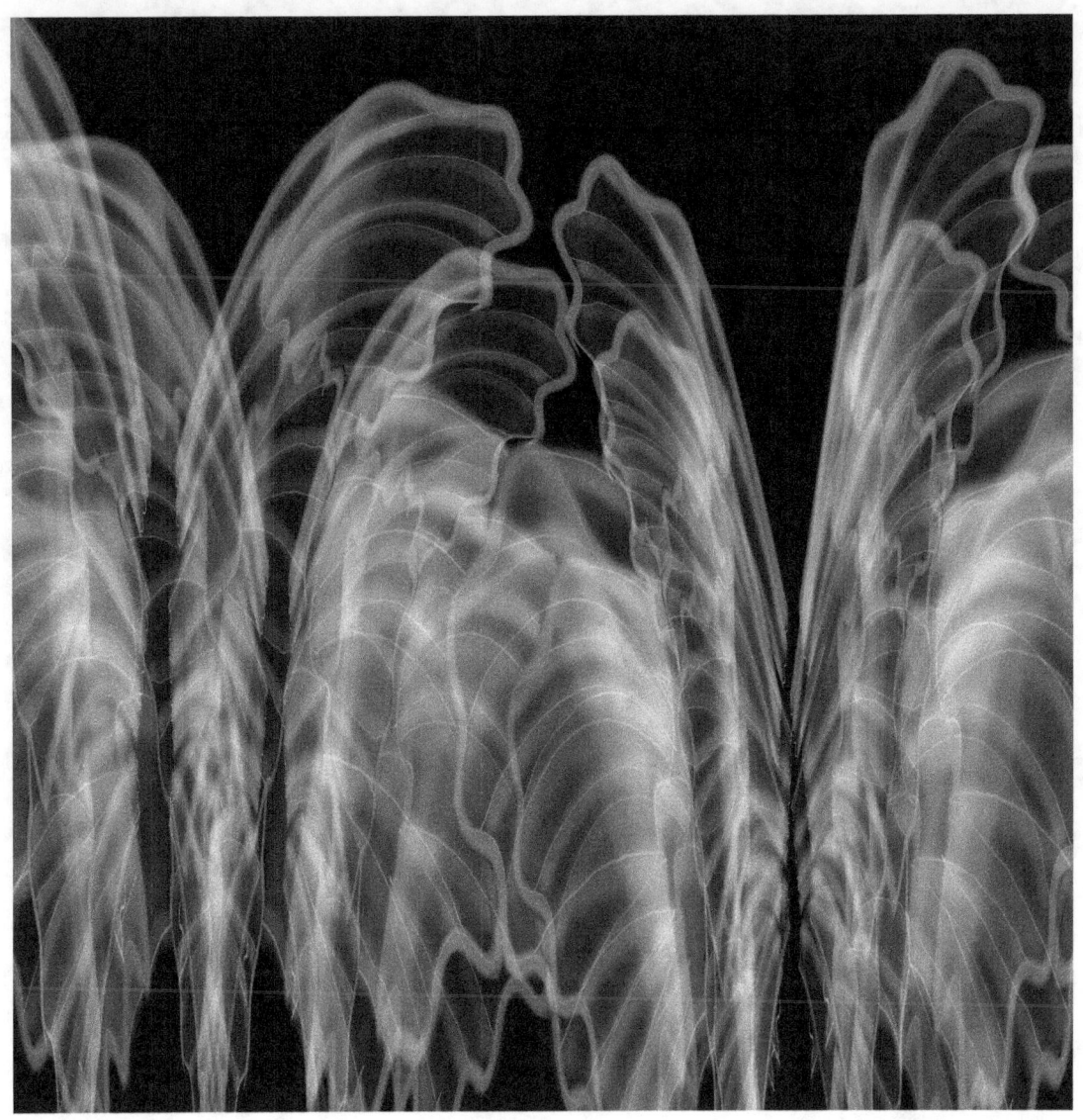

Ears

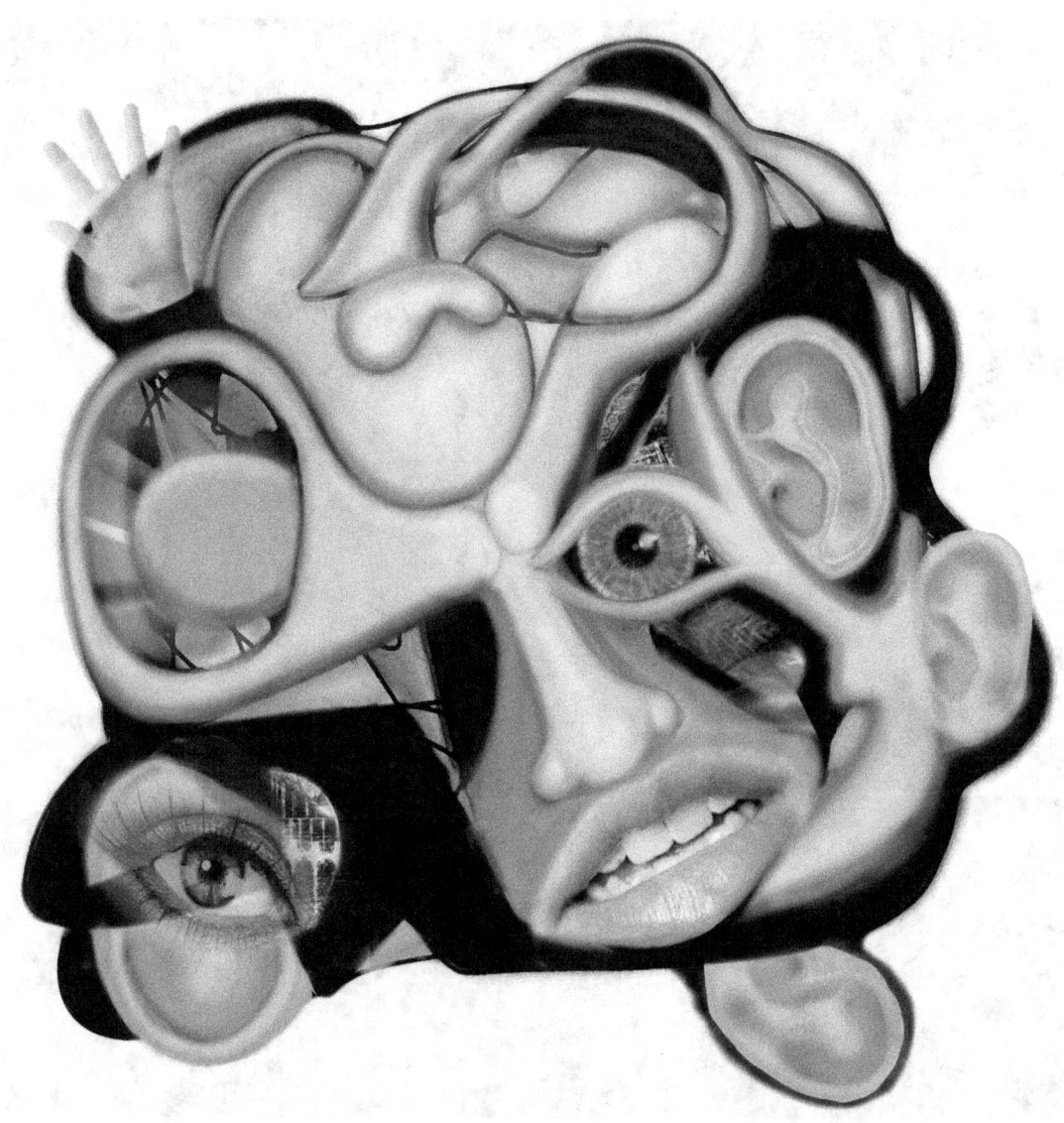

AlaParts

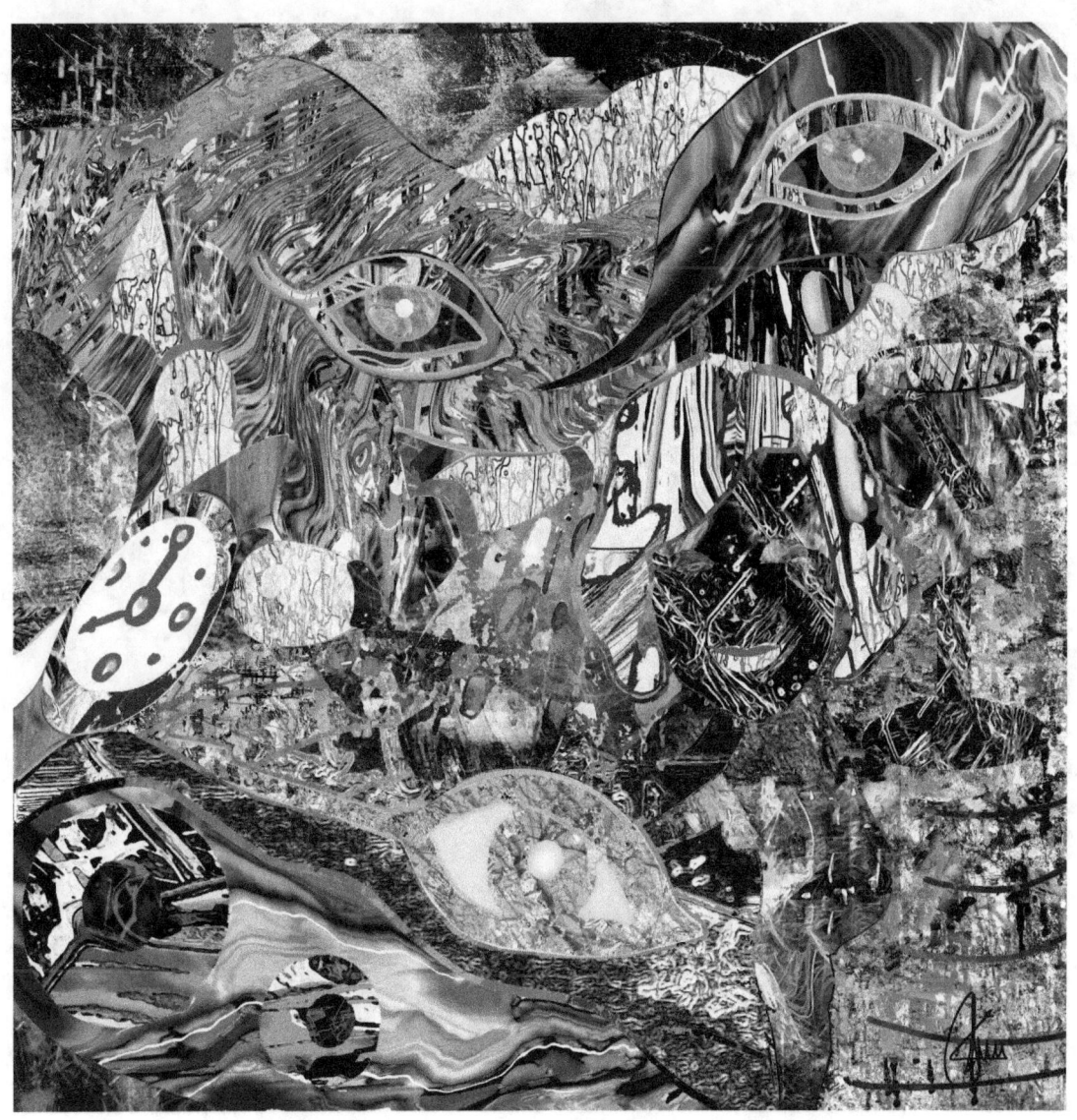

Aberdeem Proving Grounds

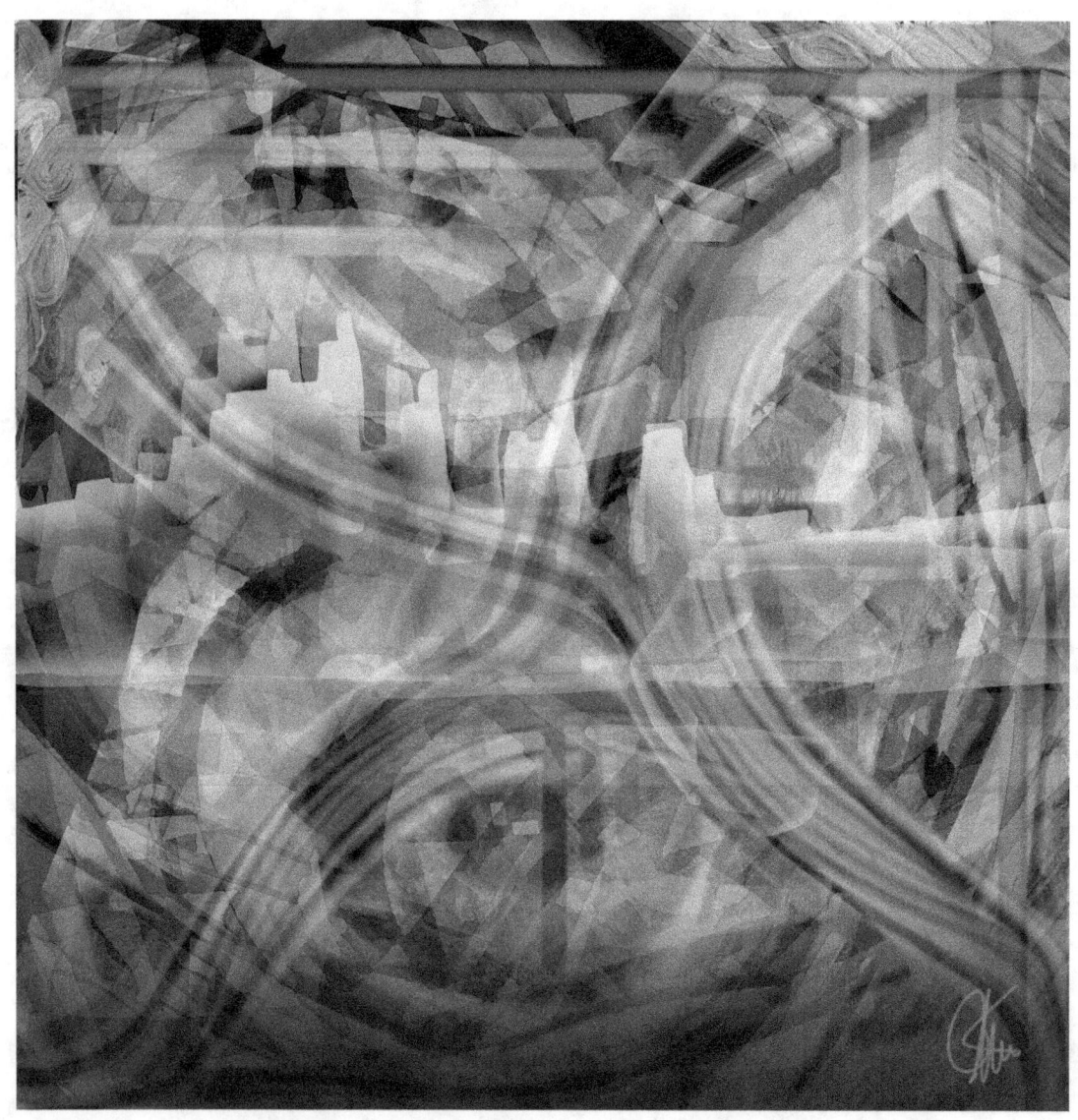

Afterlight

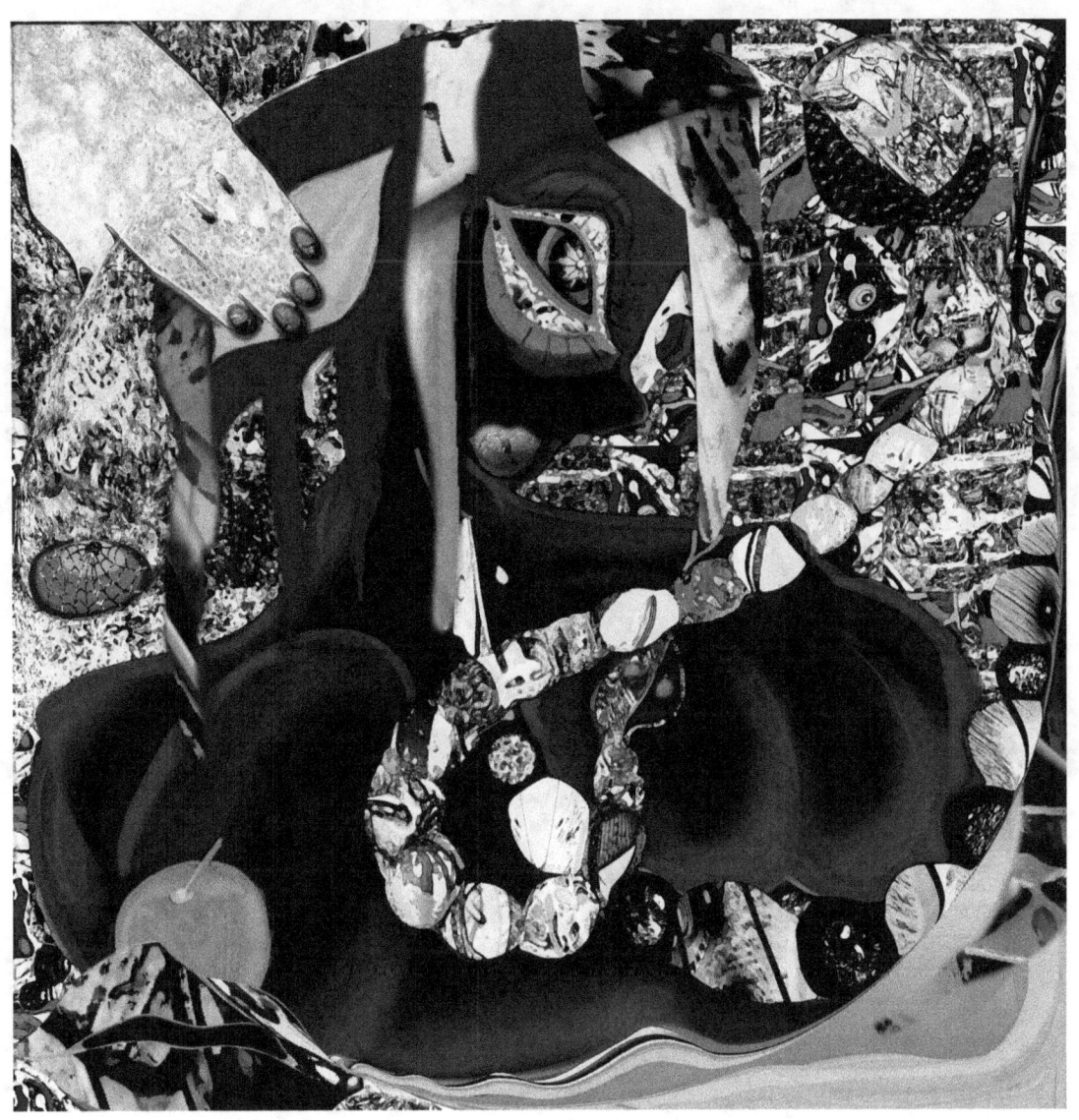

Alter
Eve

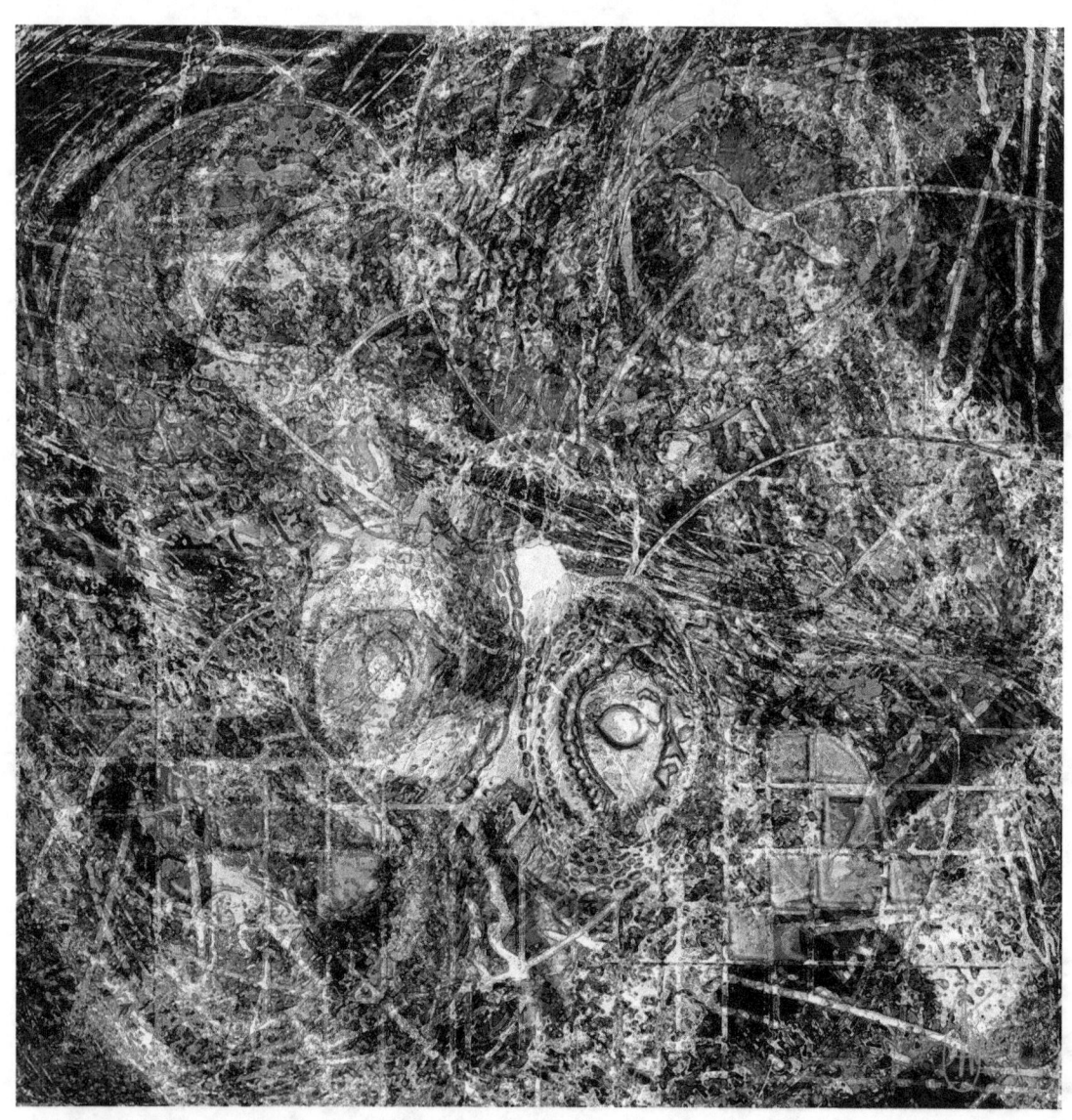

Anthropaste

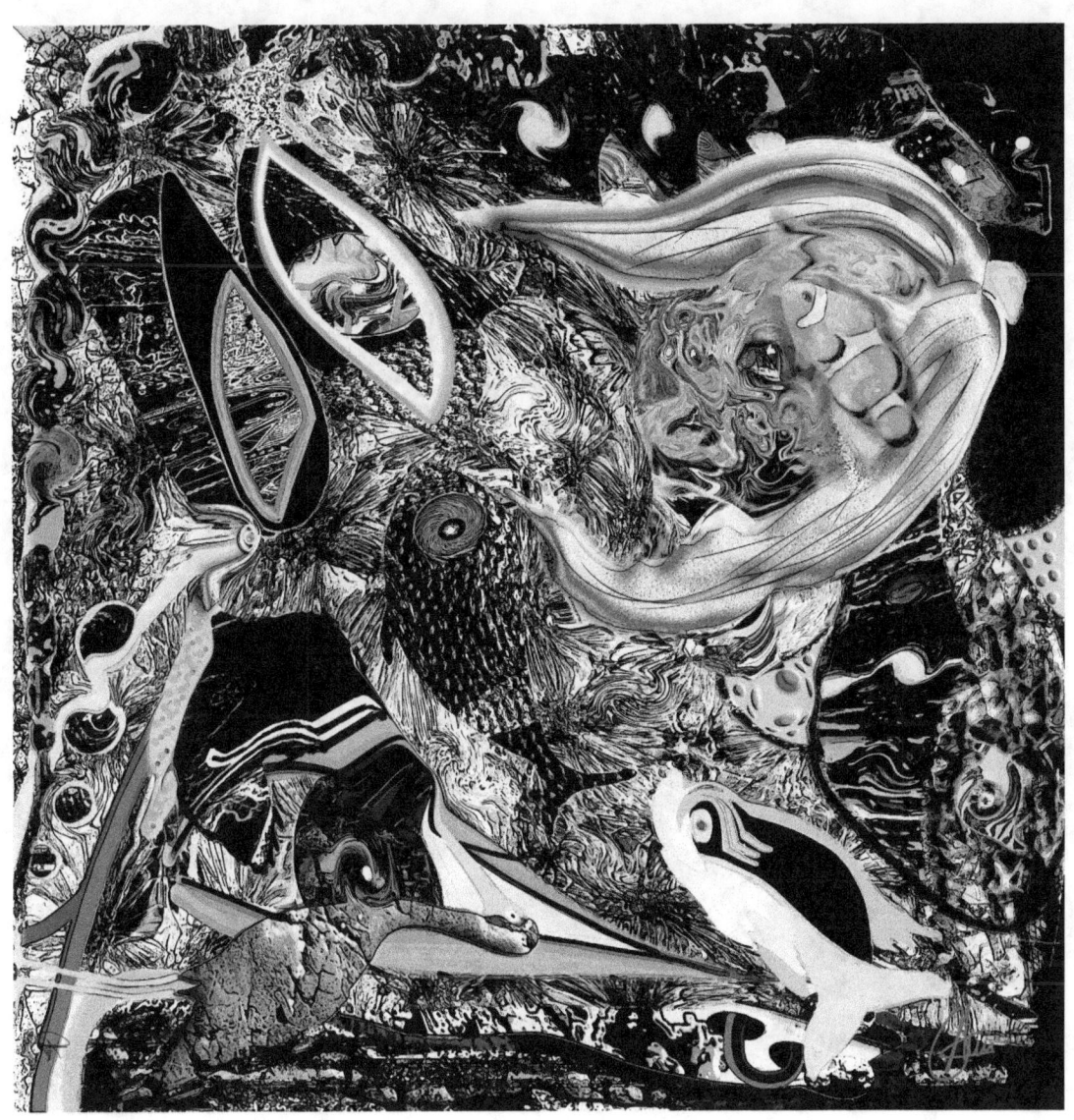

Aqua
Minerva

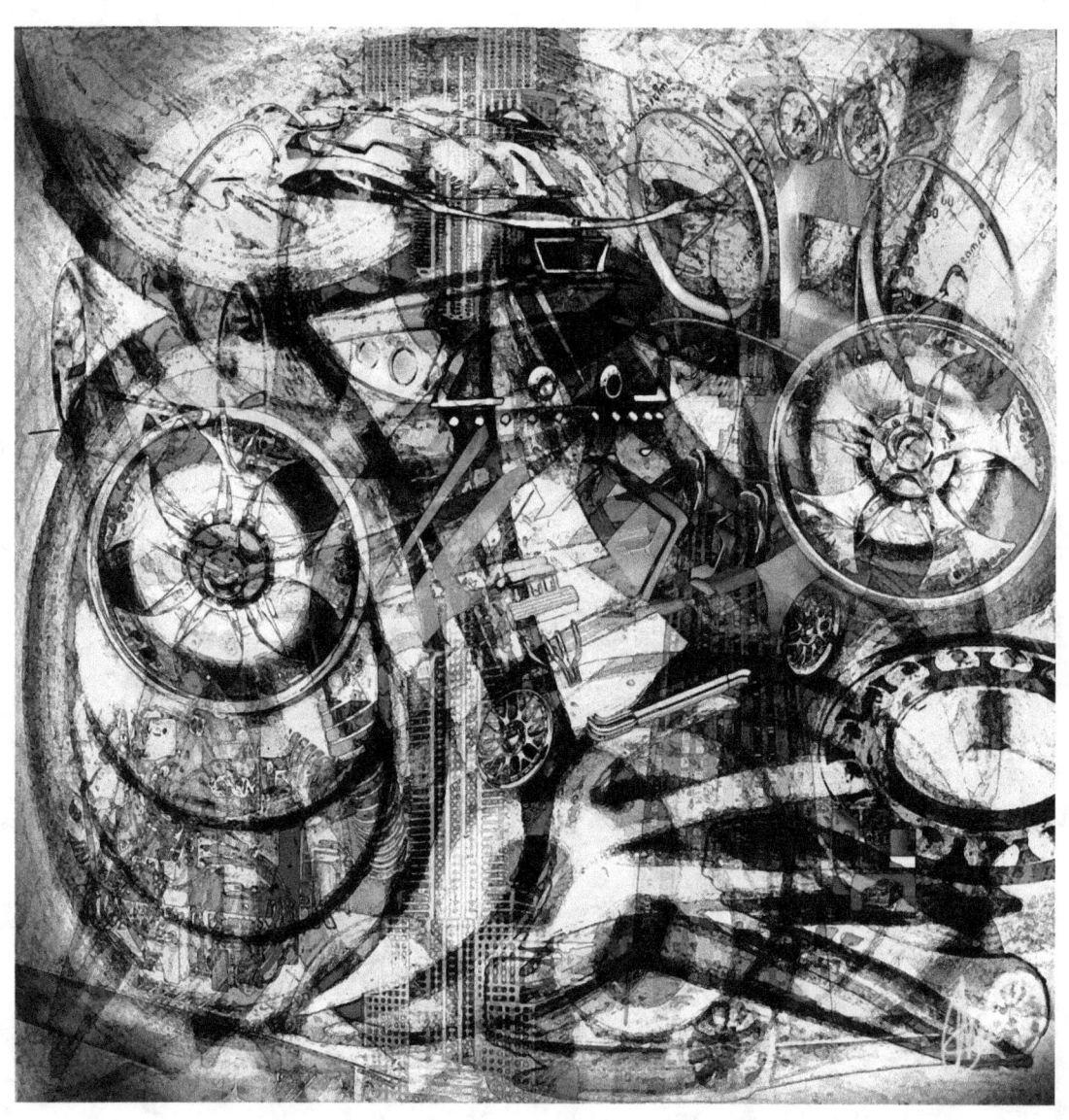

Automotopia

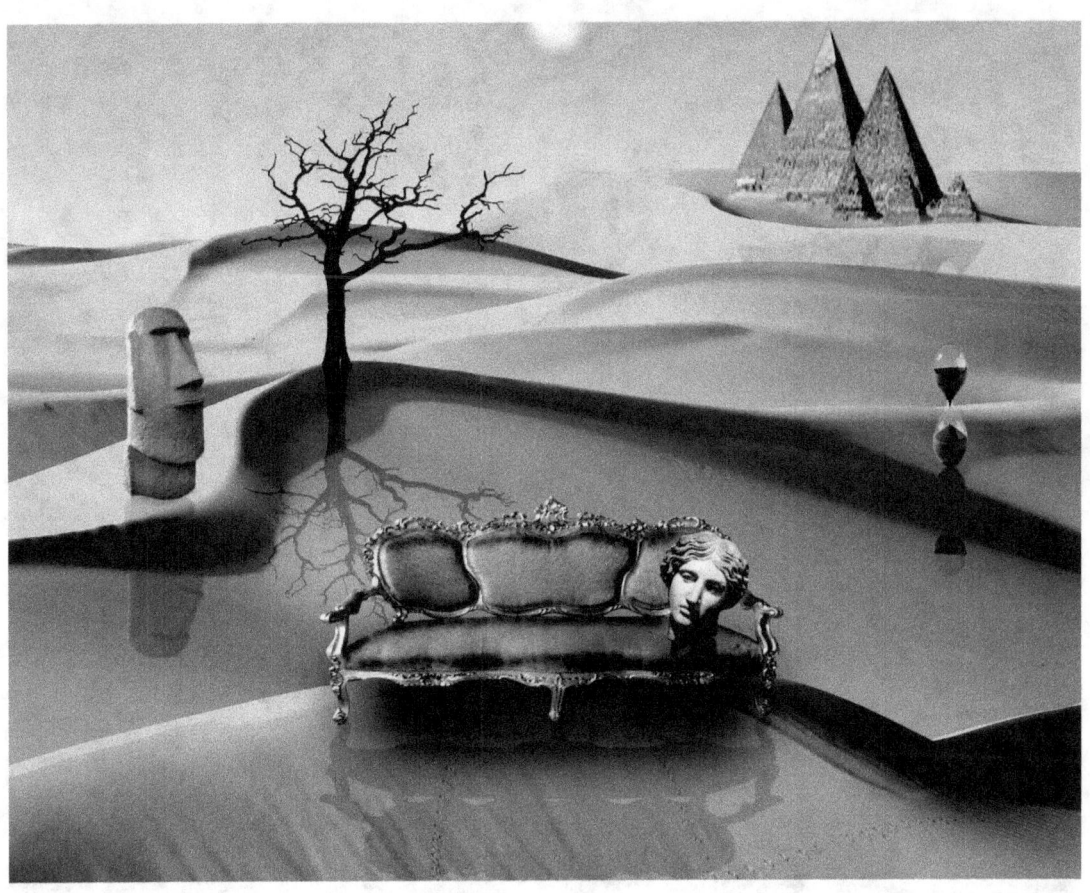

Avantoo

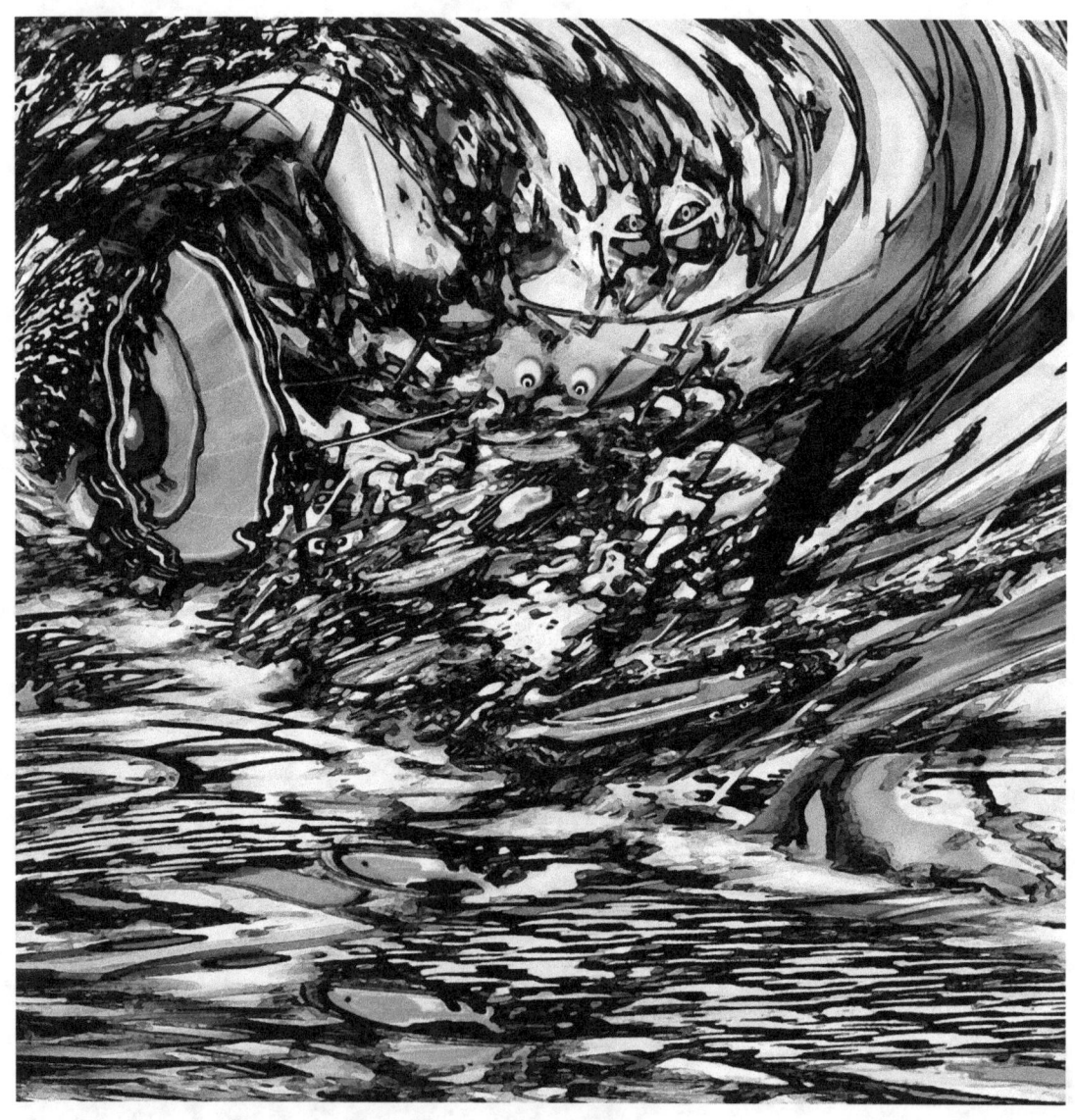

Axelo

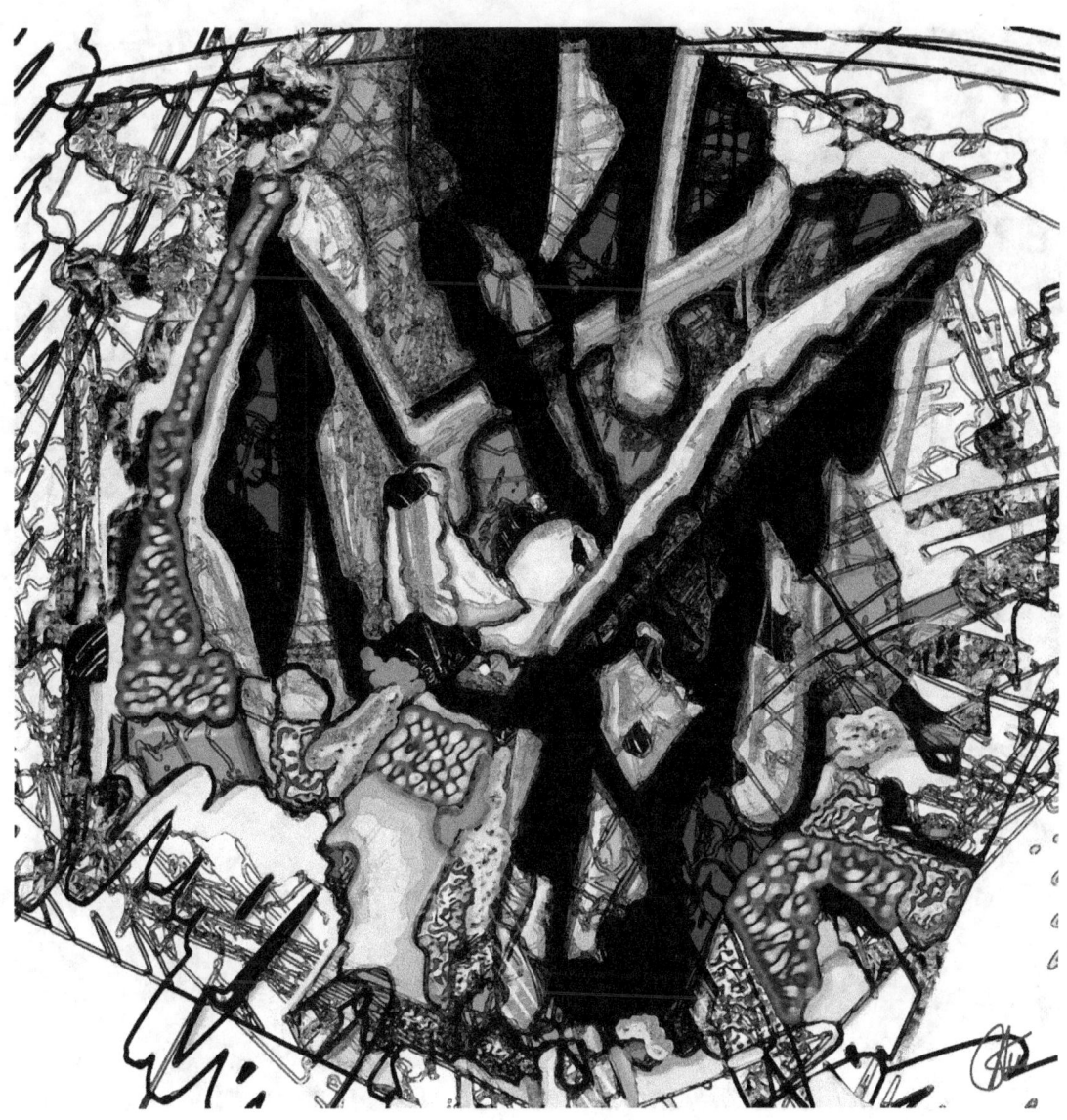

Balooga

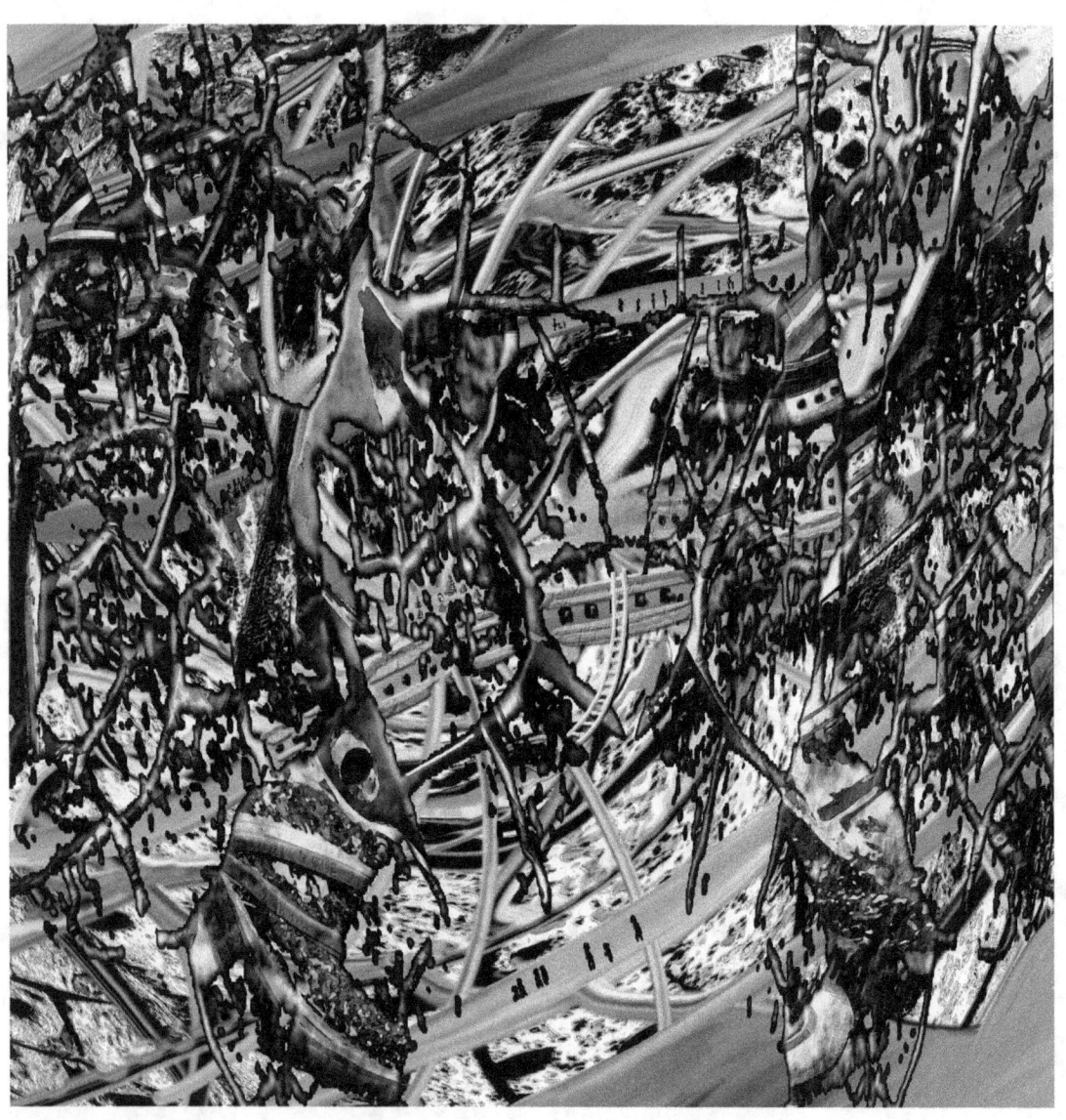

BeeGee

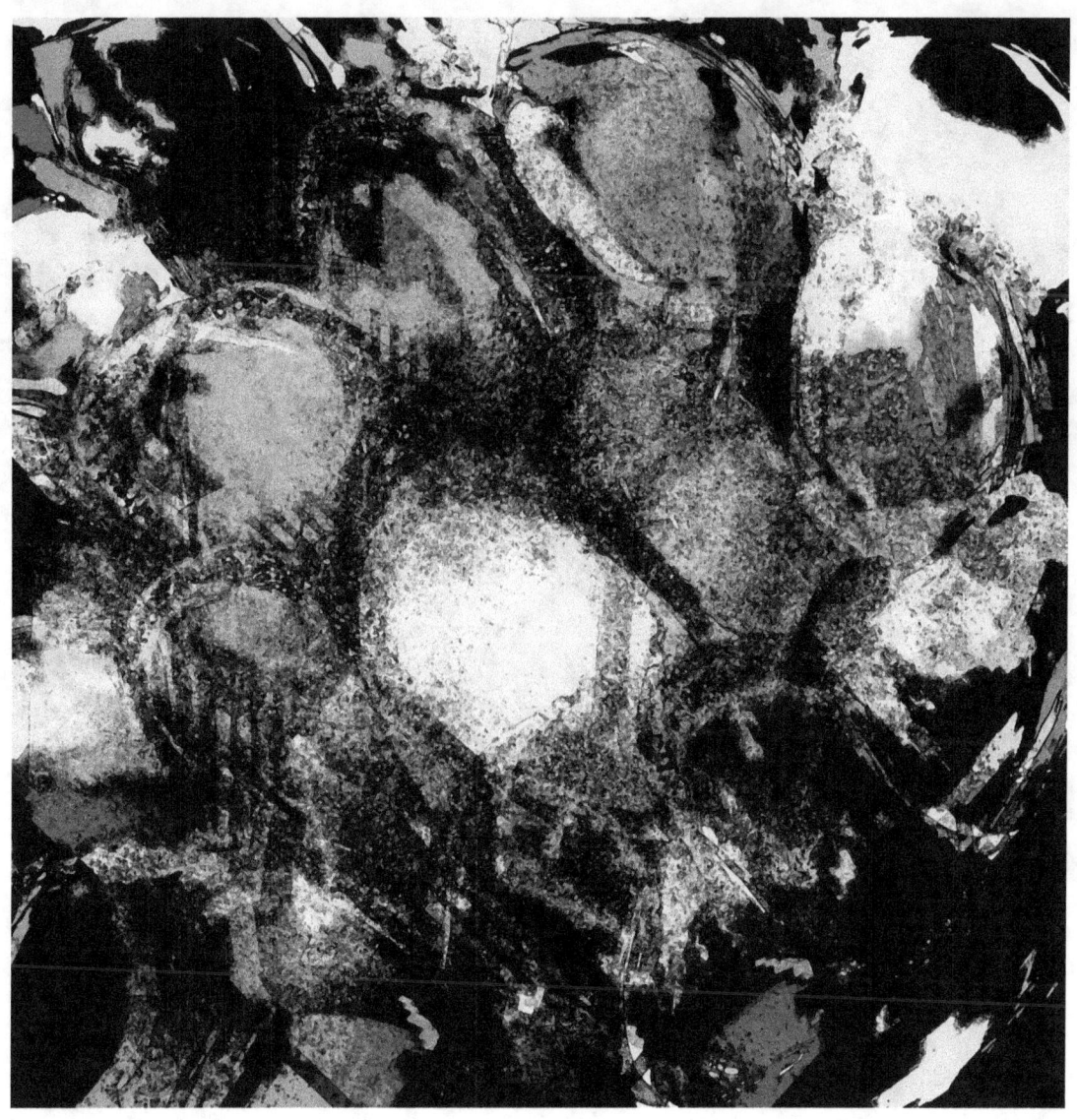

Biscuut

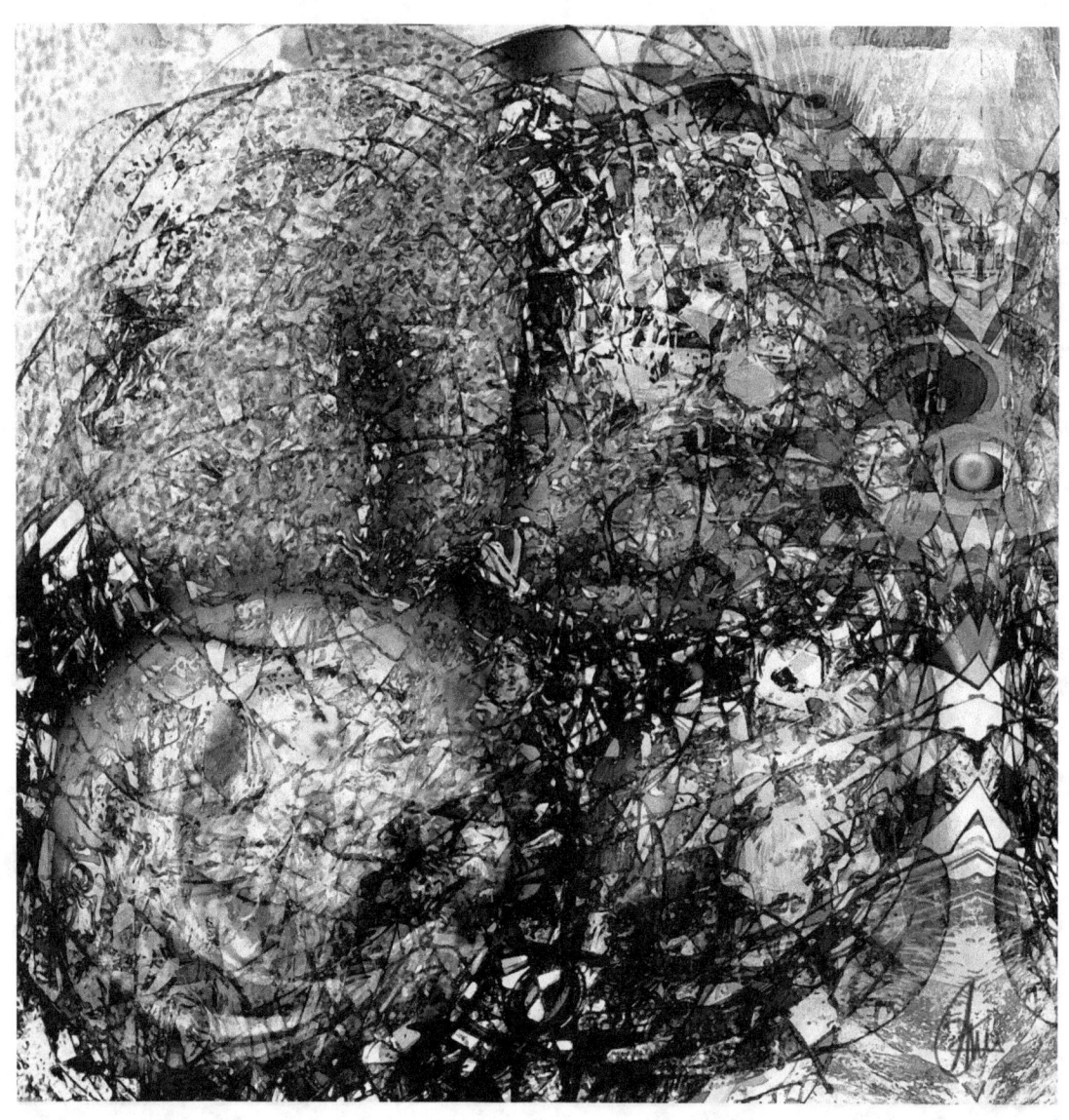

Bituminous

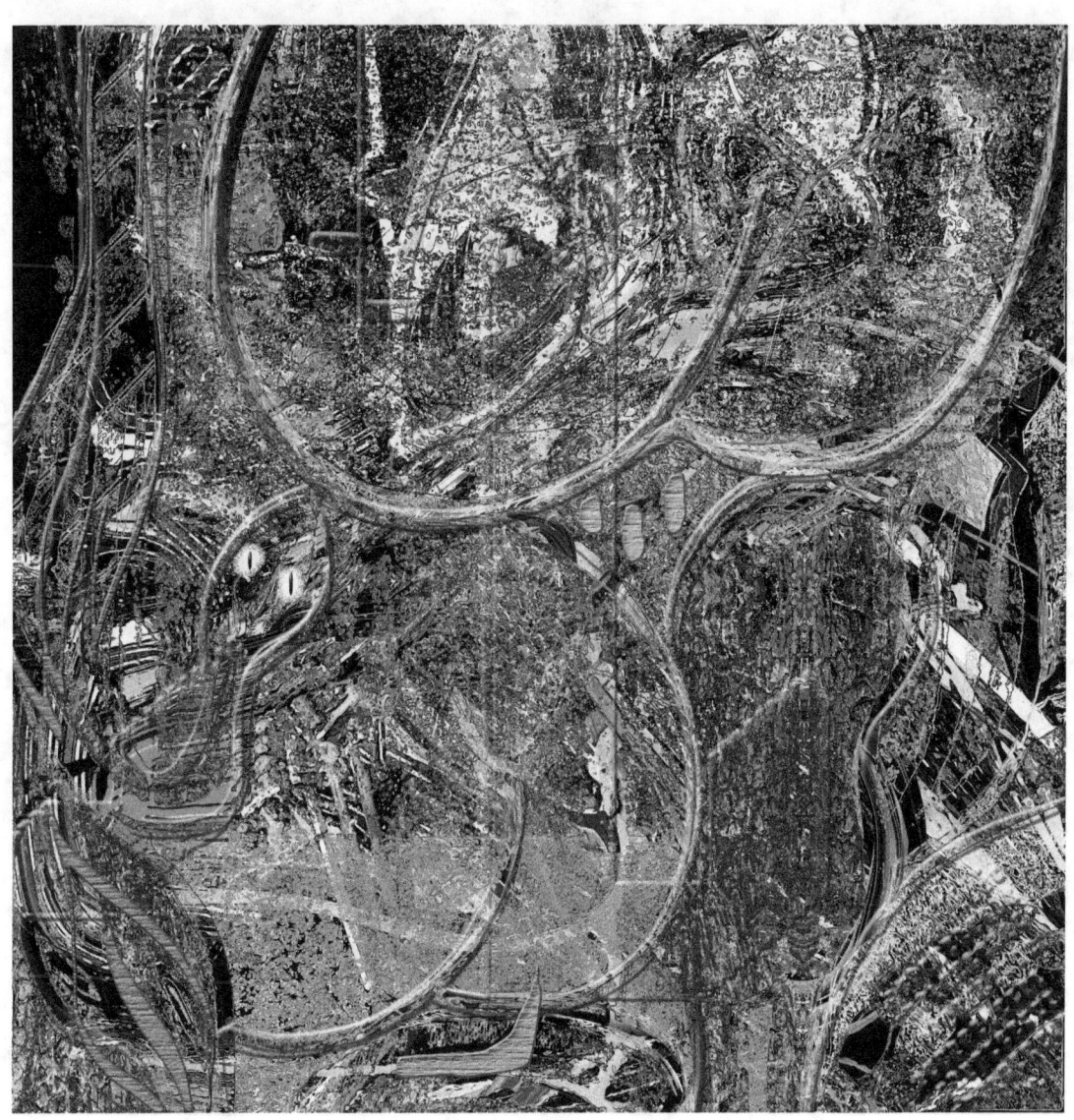

BreastRelief

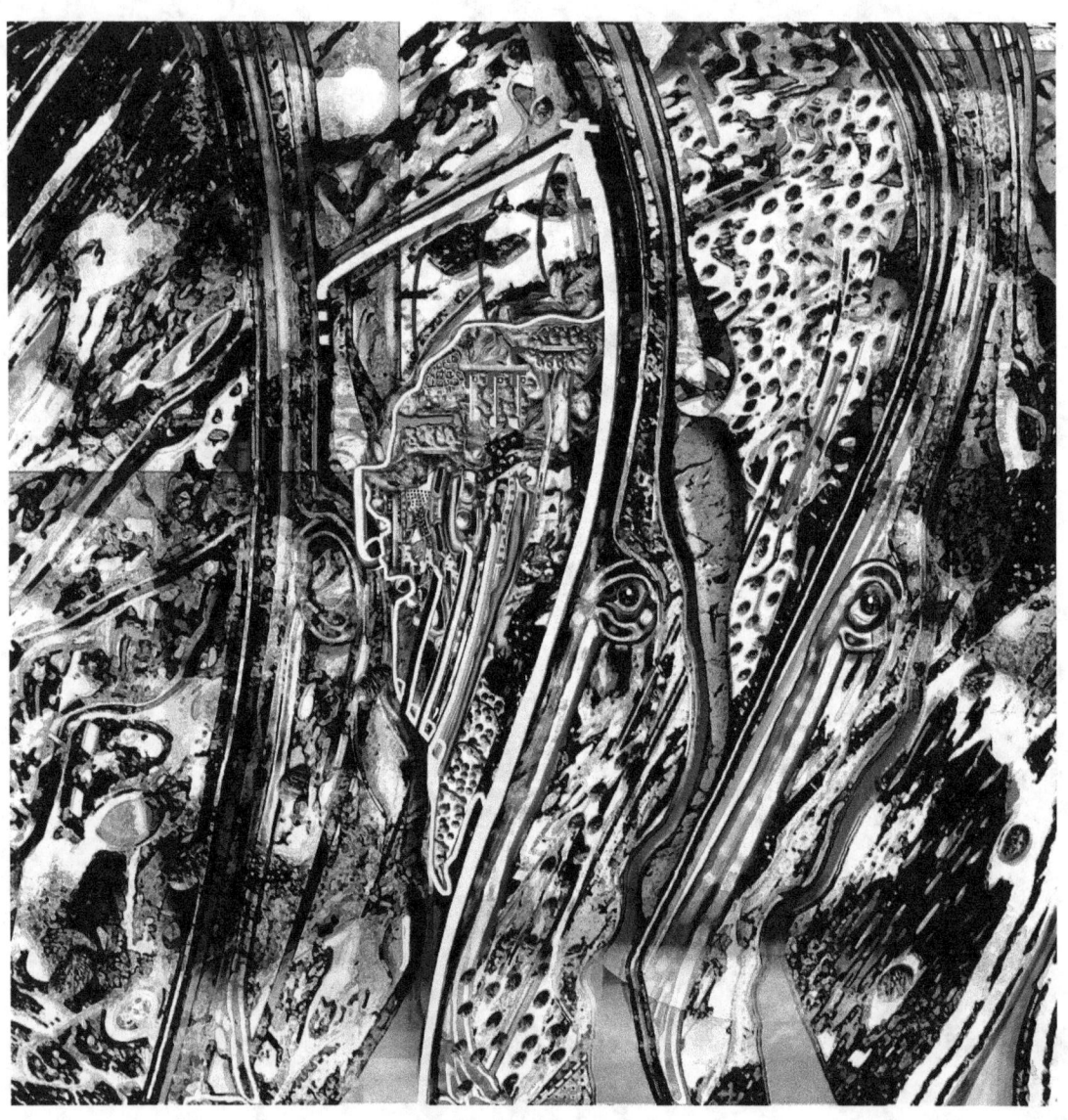

Cahass

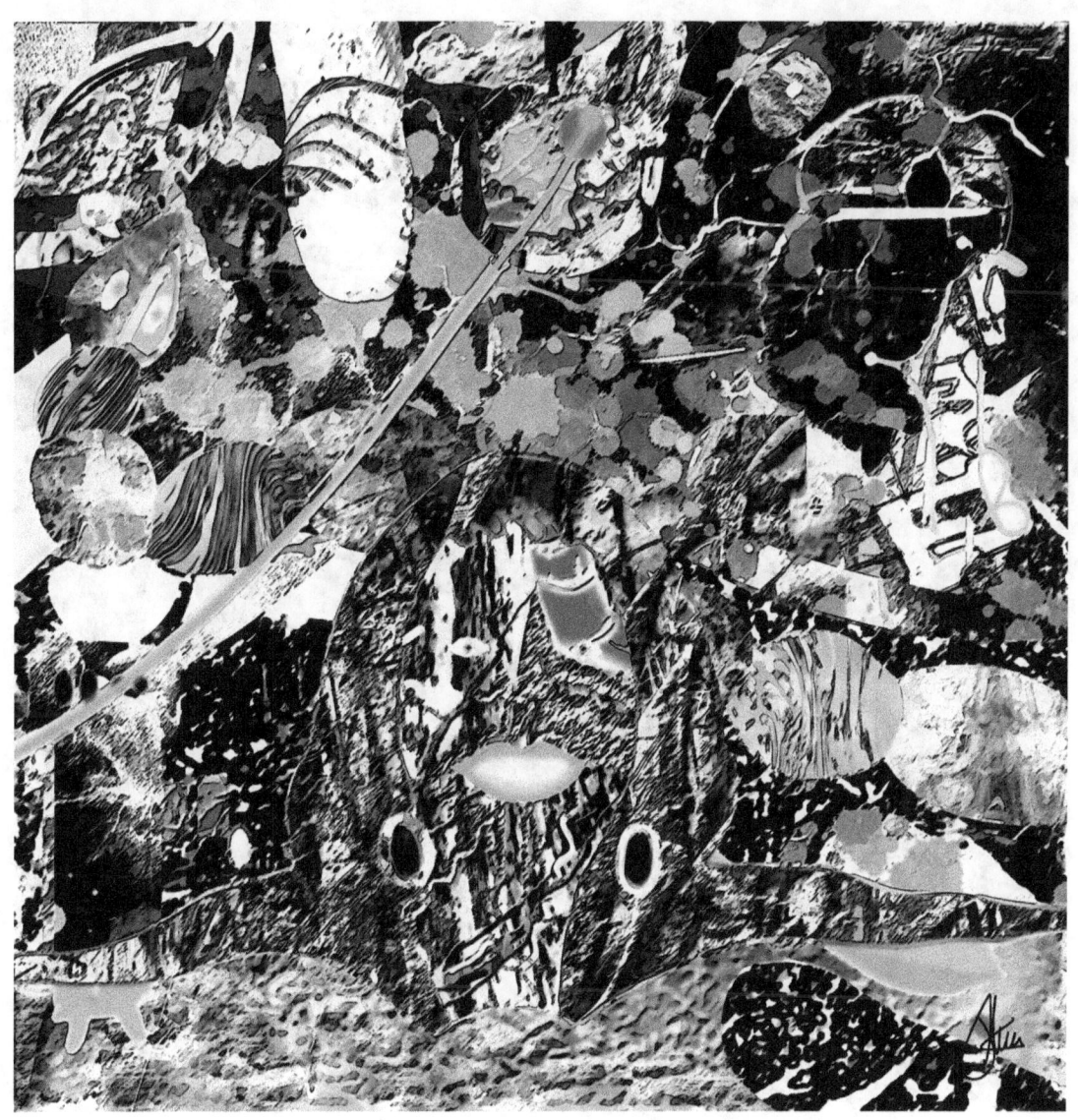

Calgon

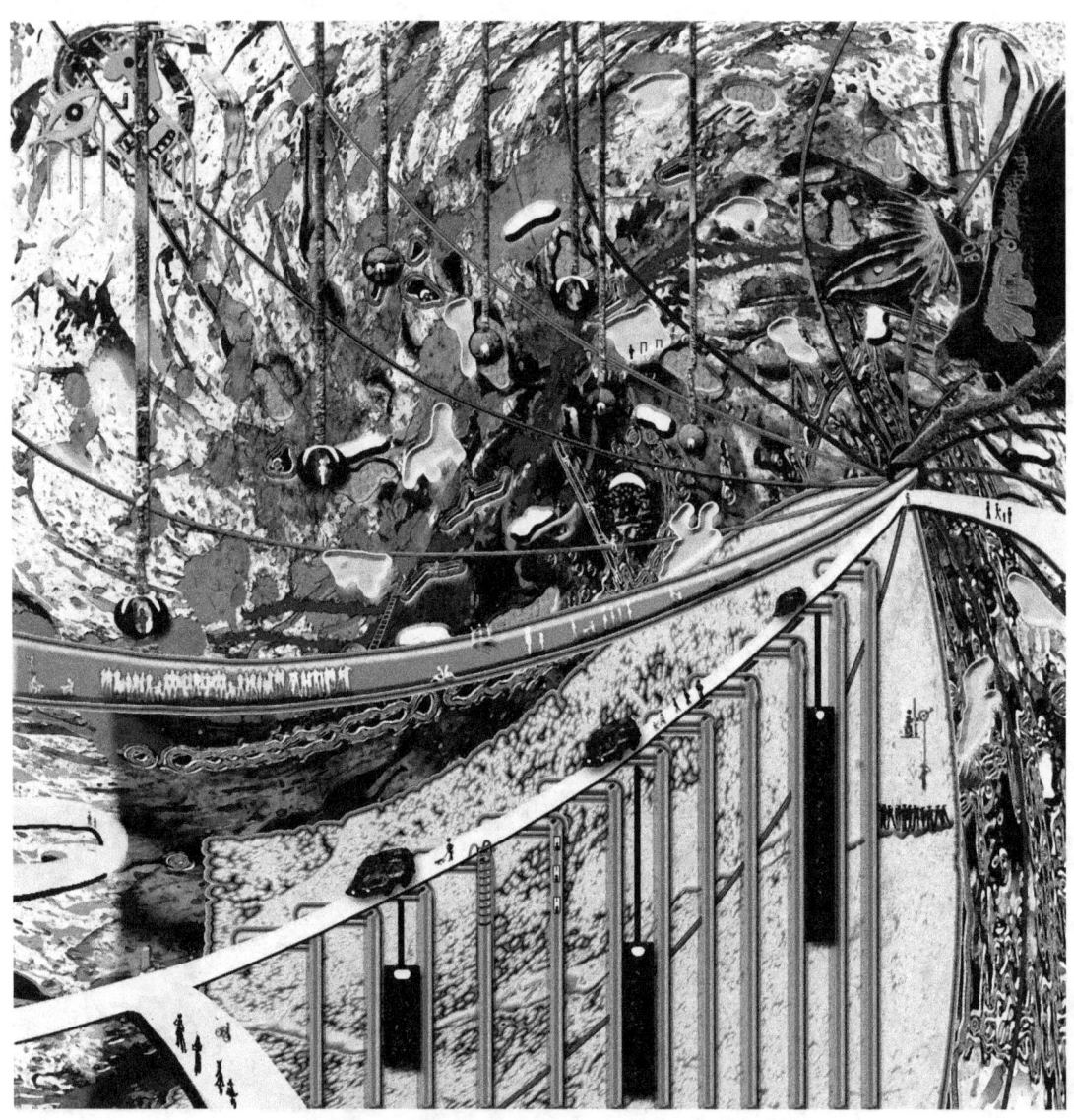

Causeway

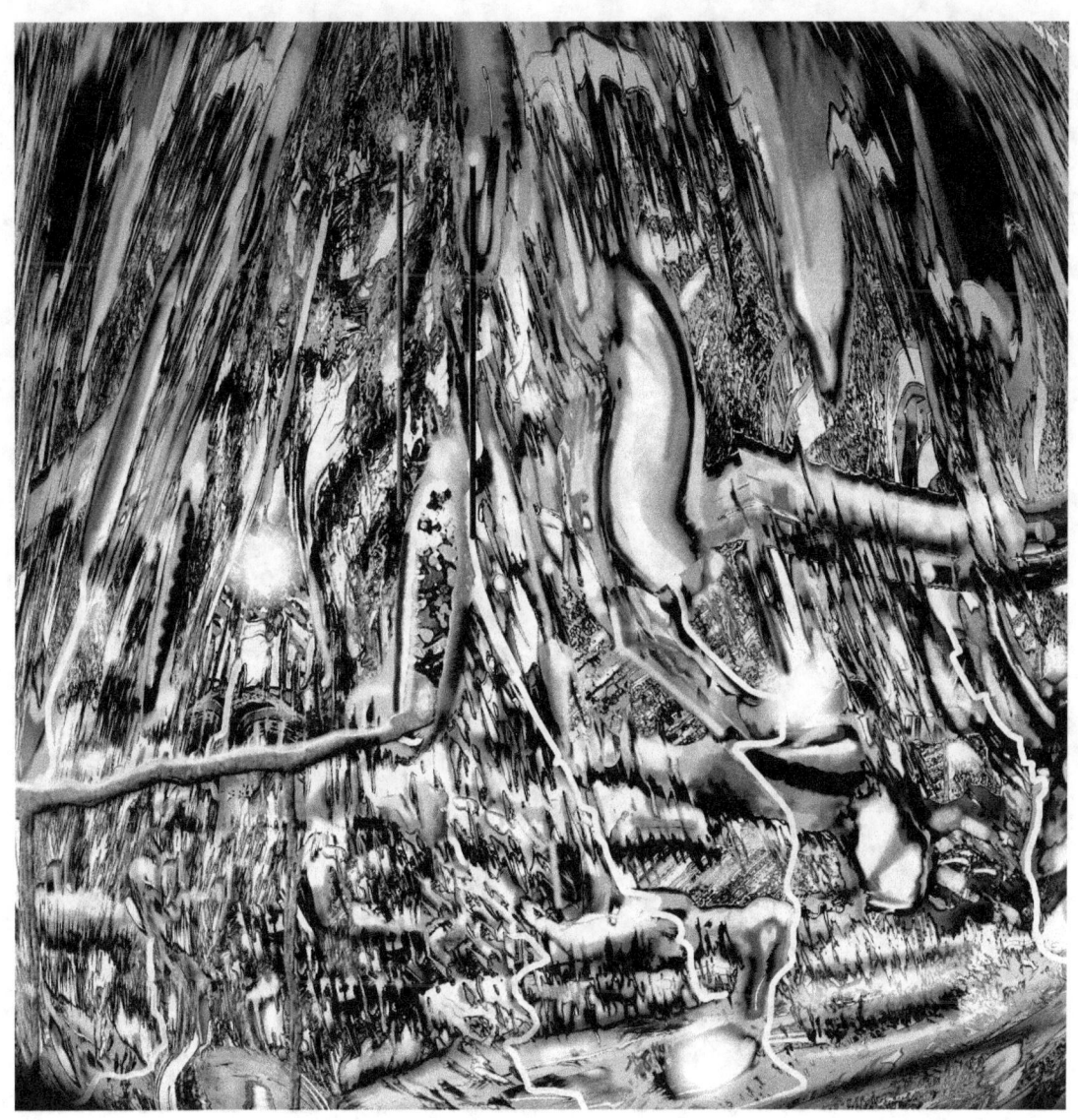

Cavern of
Cavoo

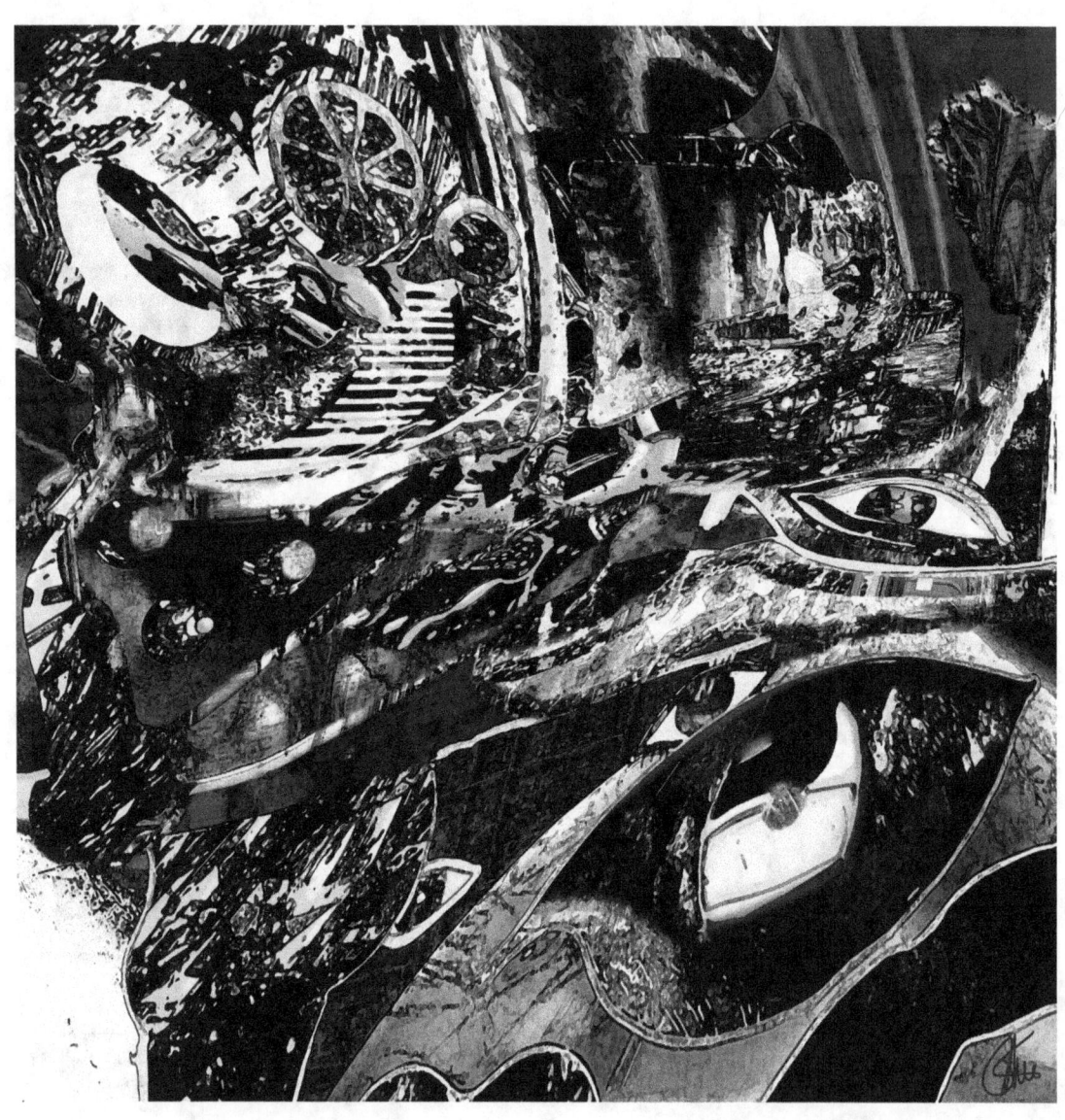

Cellar of Abandoned Dreams

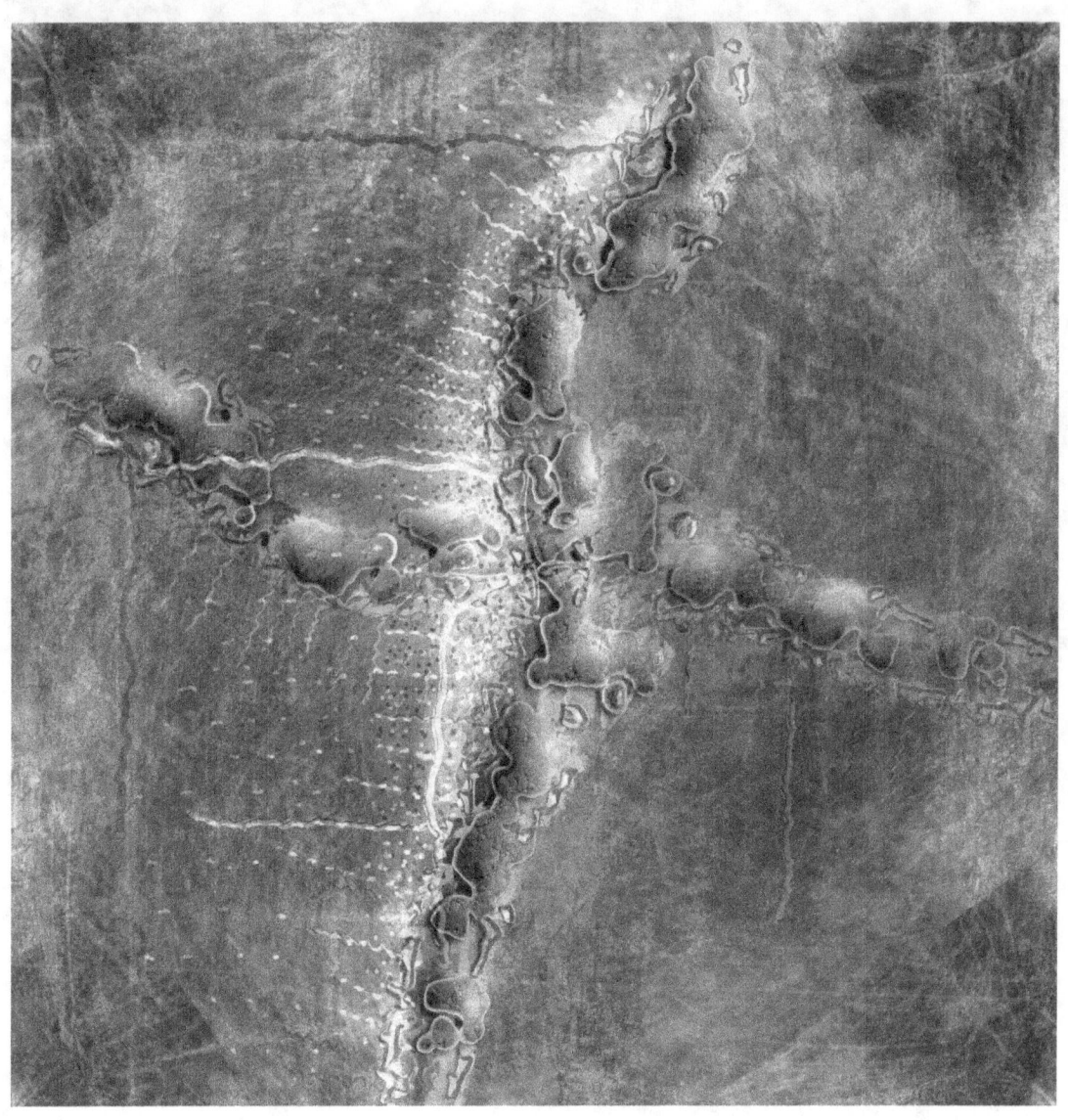

Chakrascendo

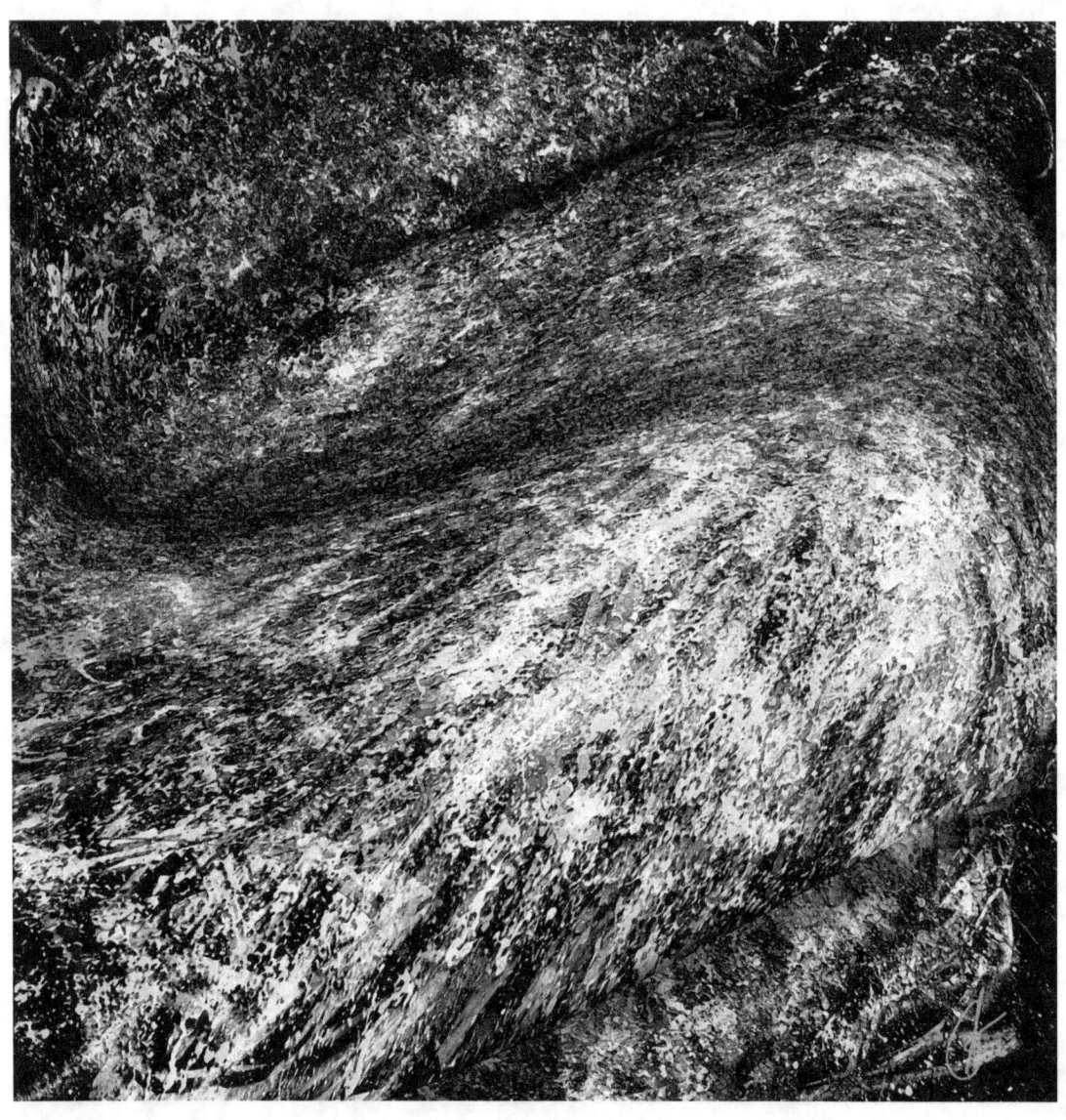

Chuggle
Dust

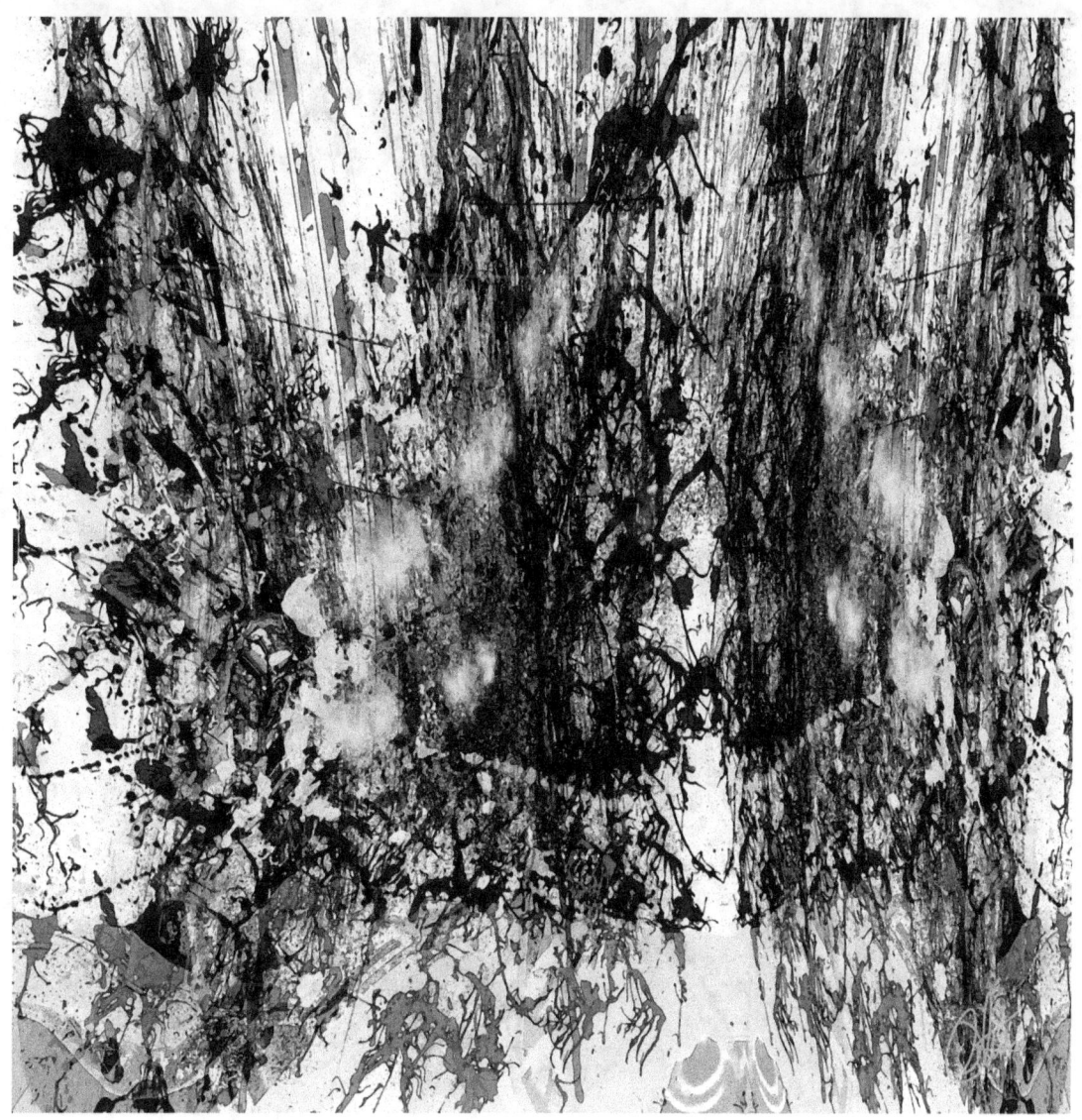

Cocytus

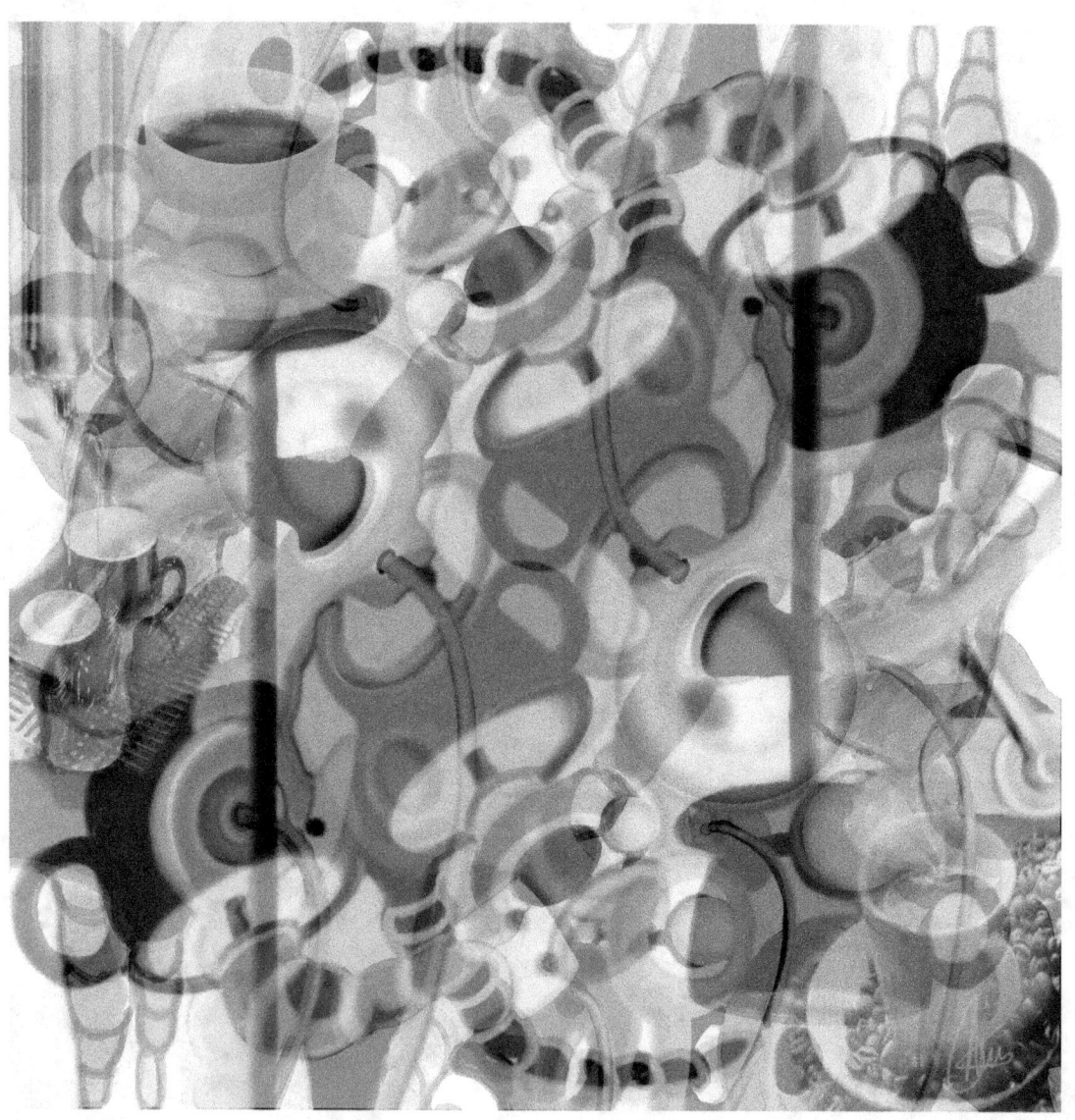

Coffee
Cups

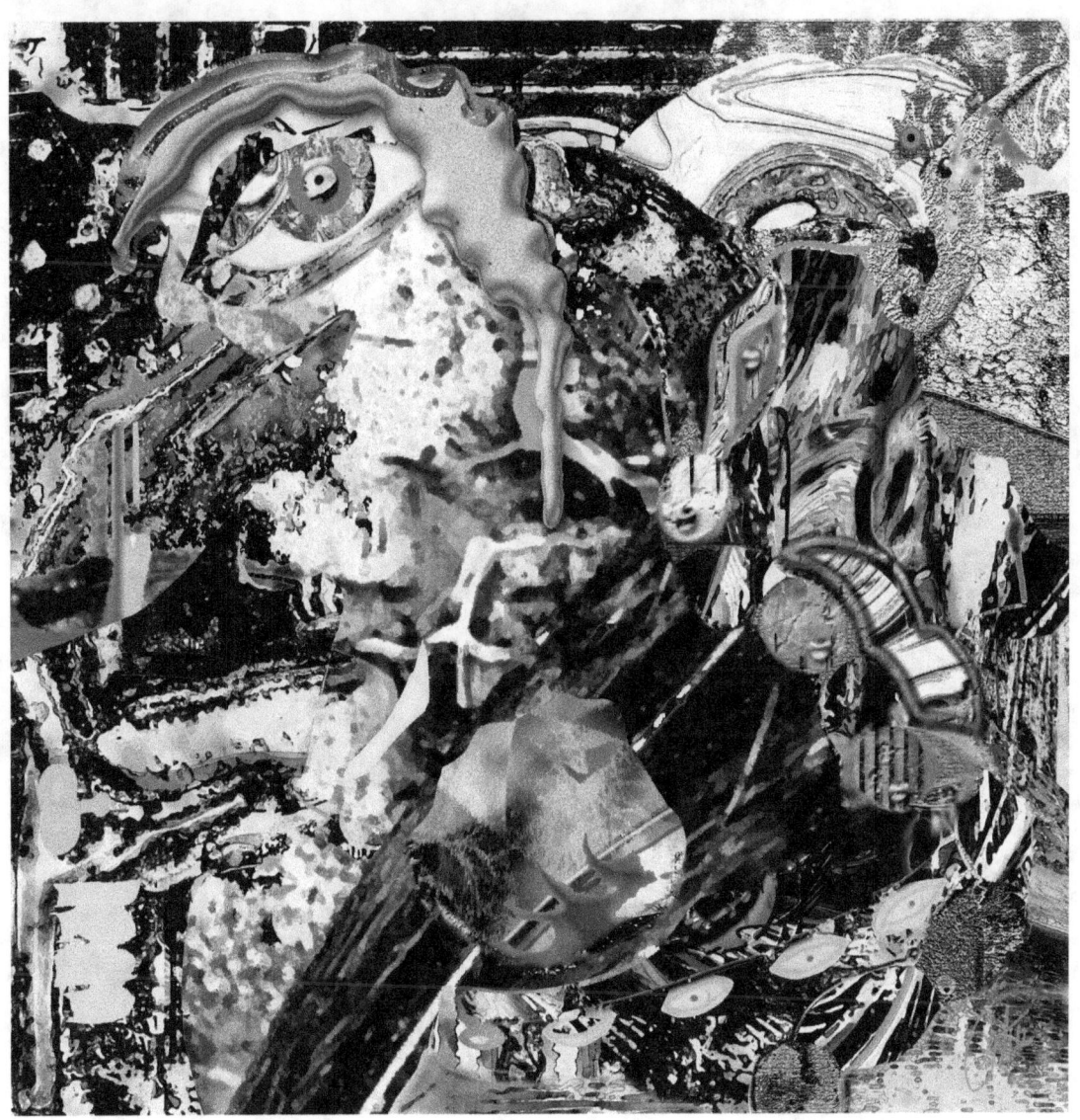

Callagio

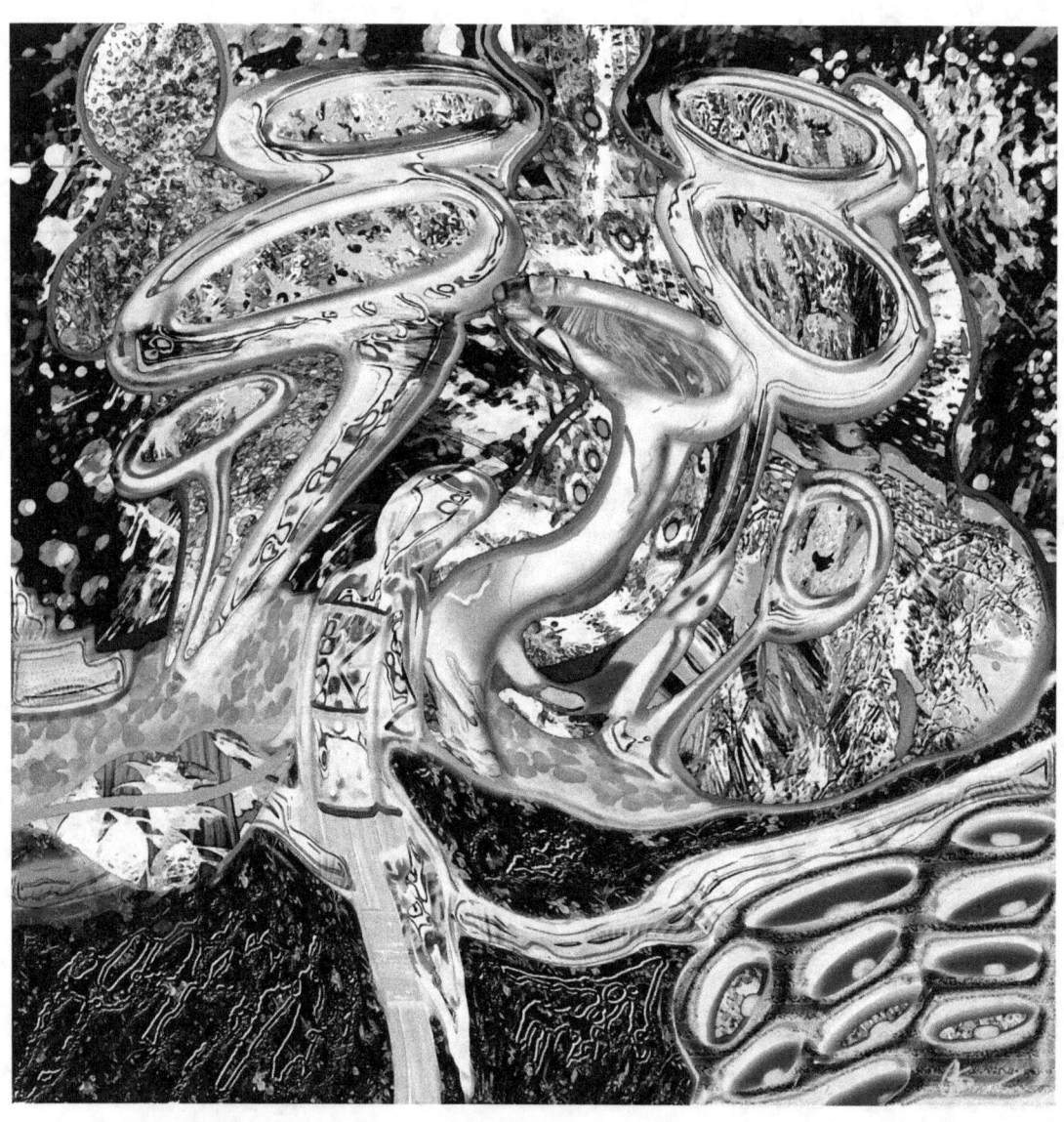

Collusum Crossum

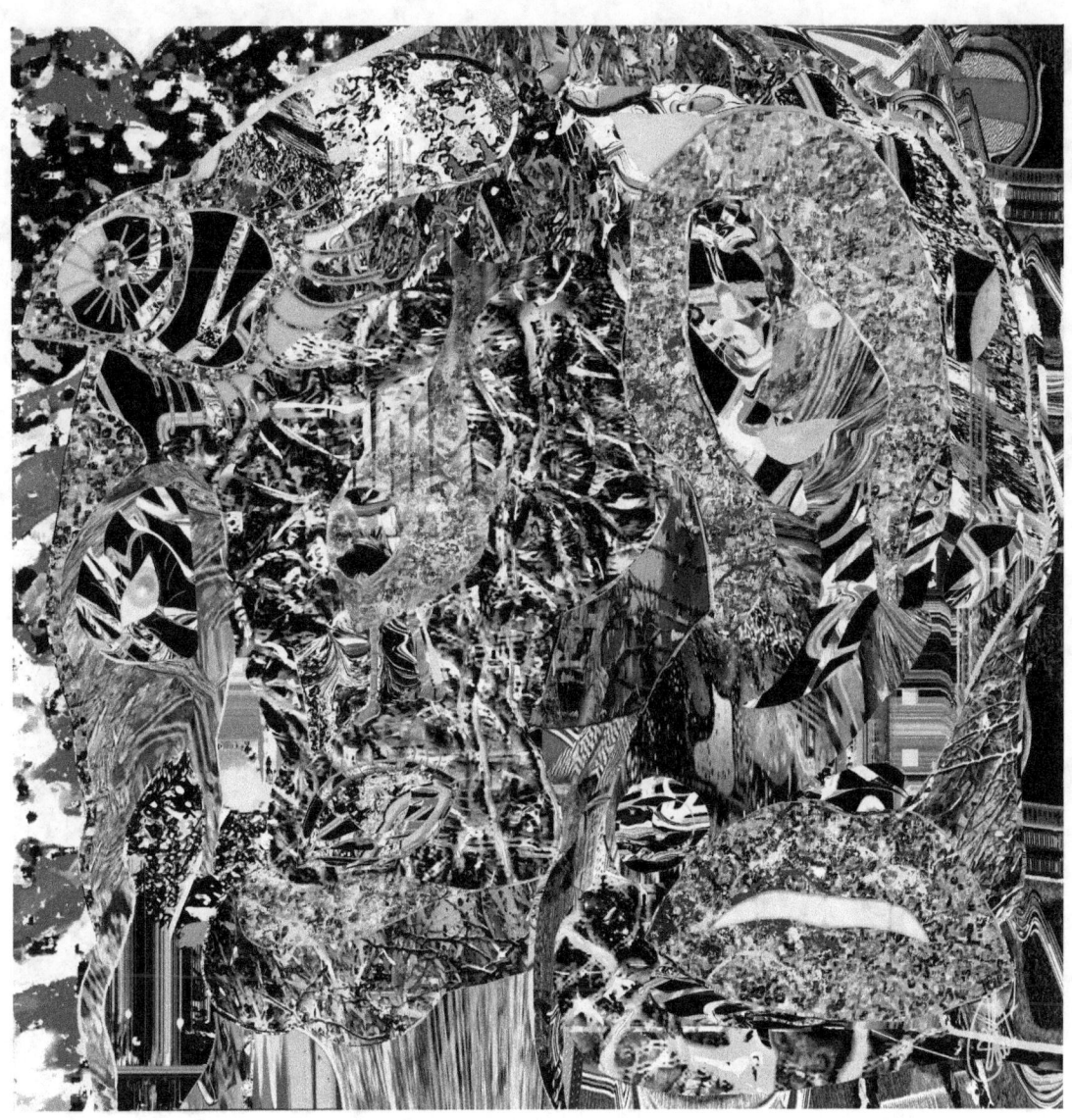

Color Me
Candice

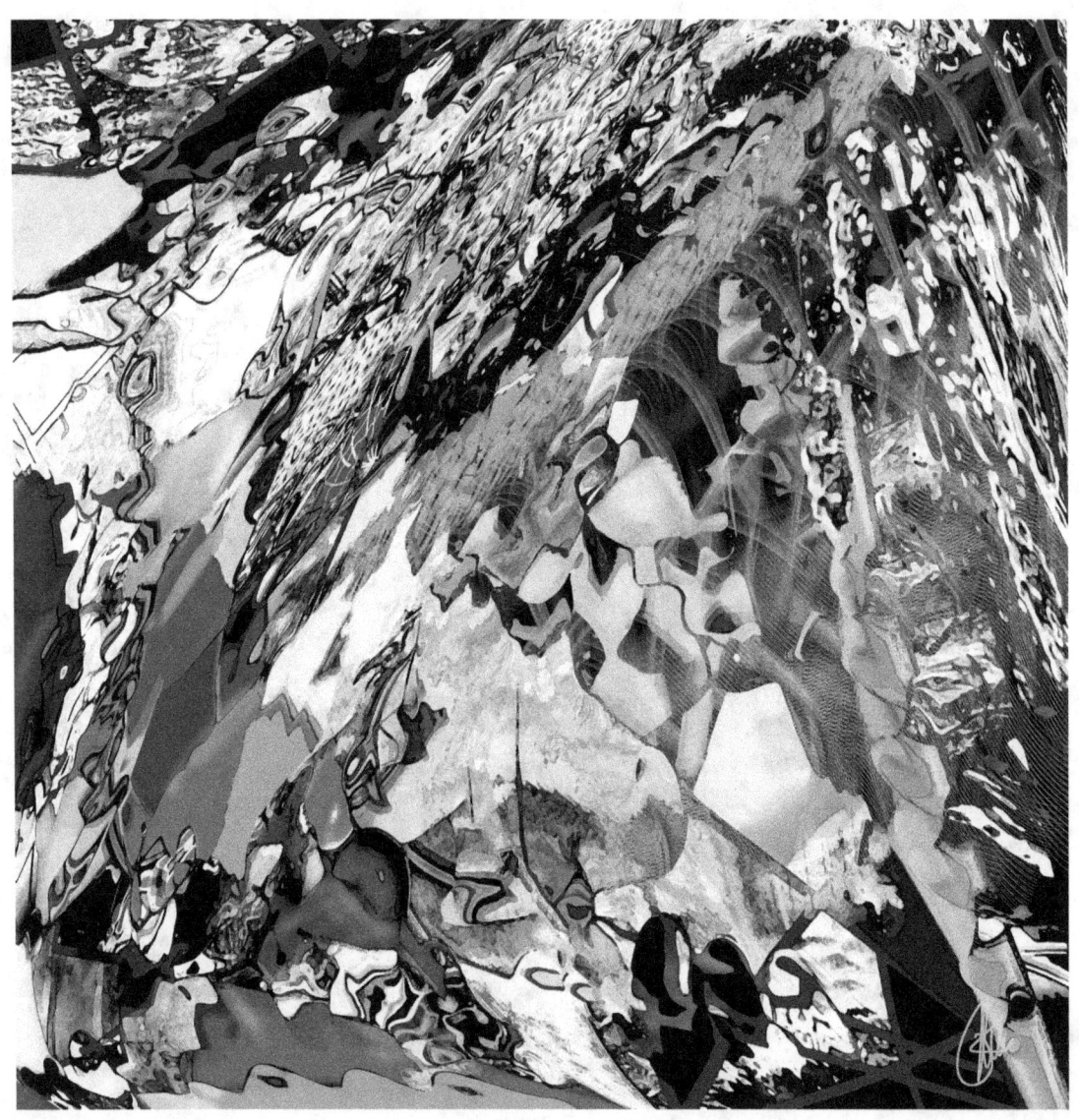

Colorlanch

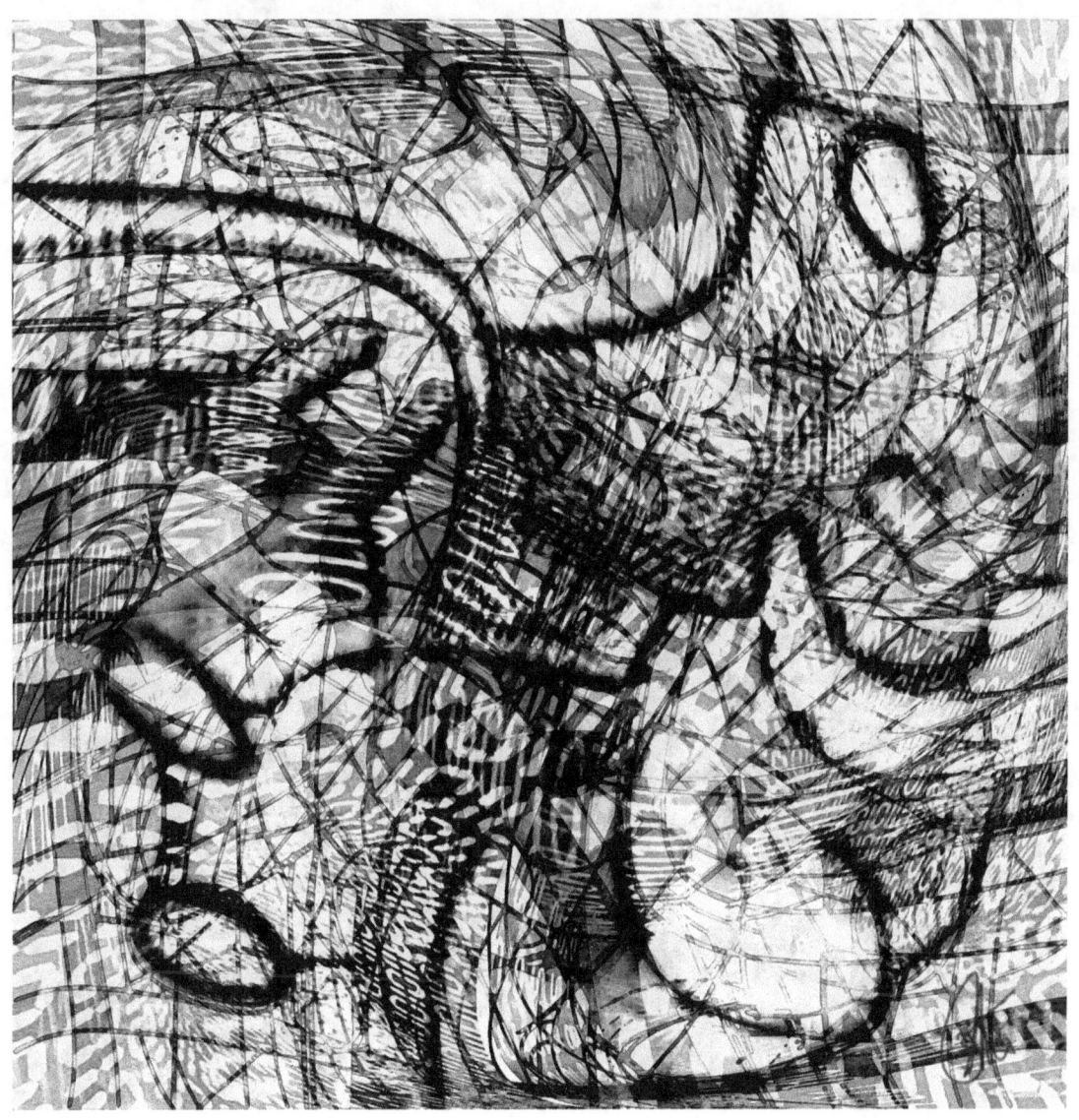

Computer
VIrus

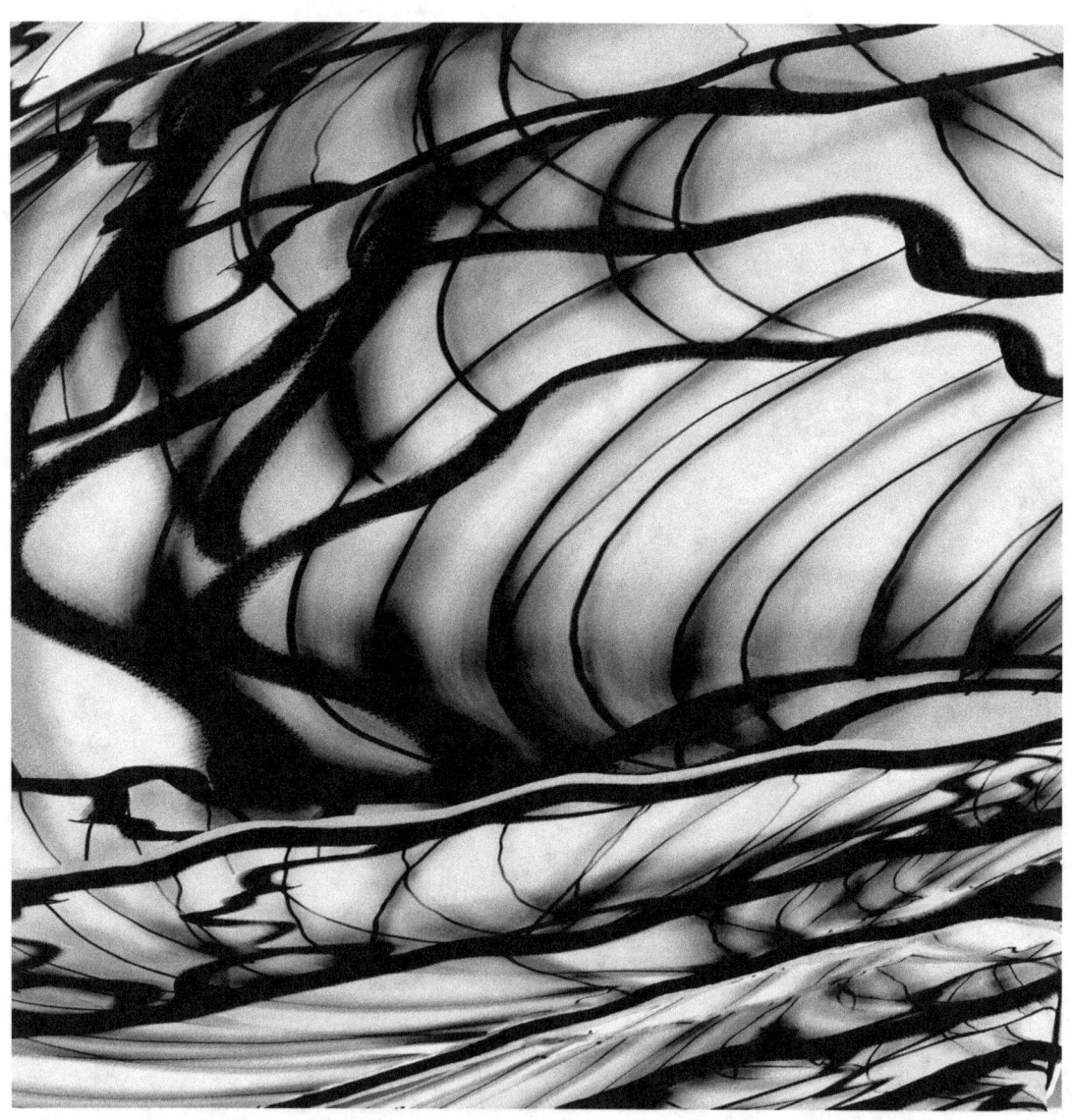

Conjecture

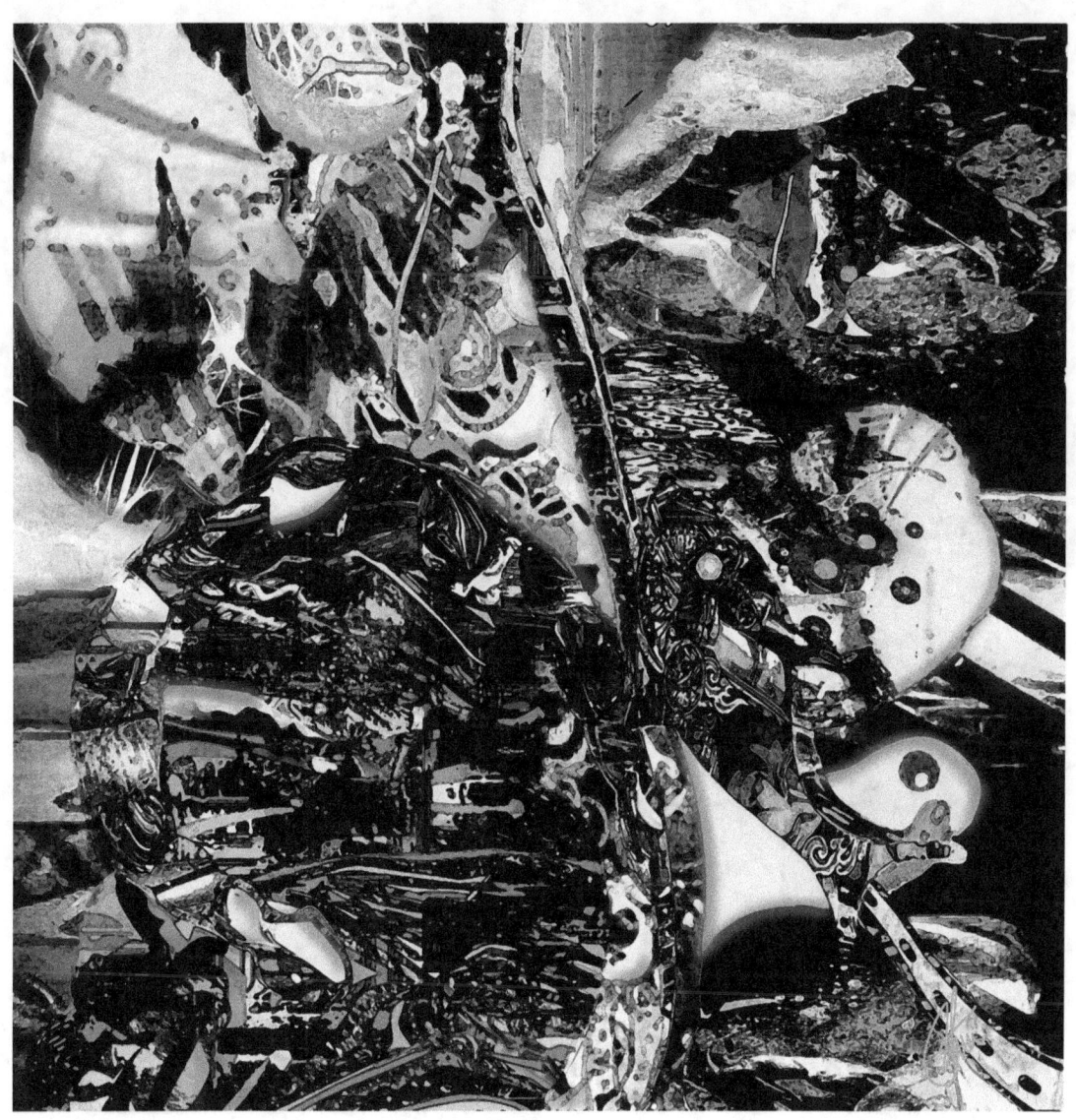

Conjunctivotion

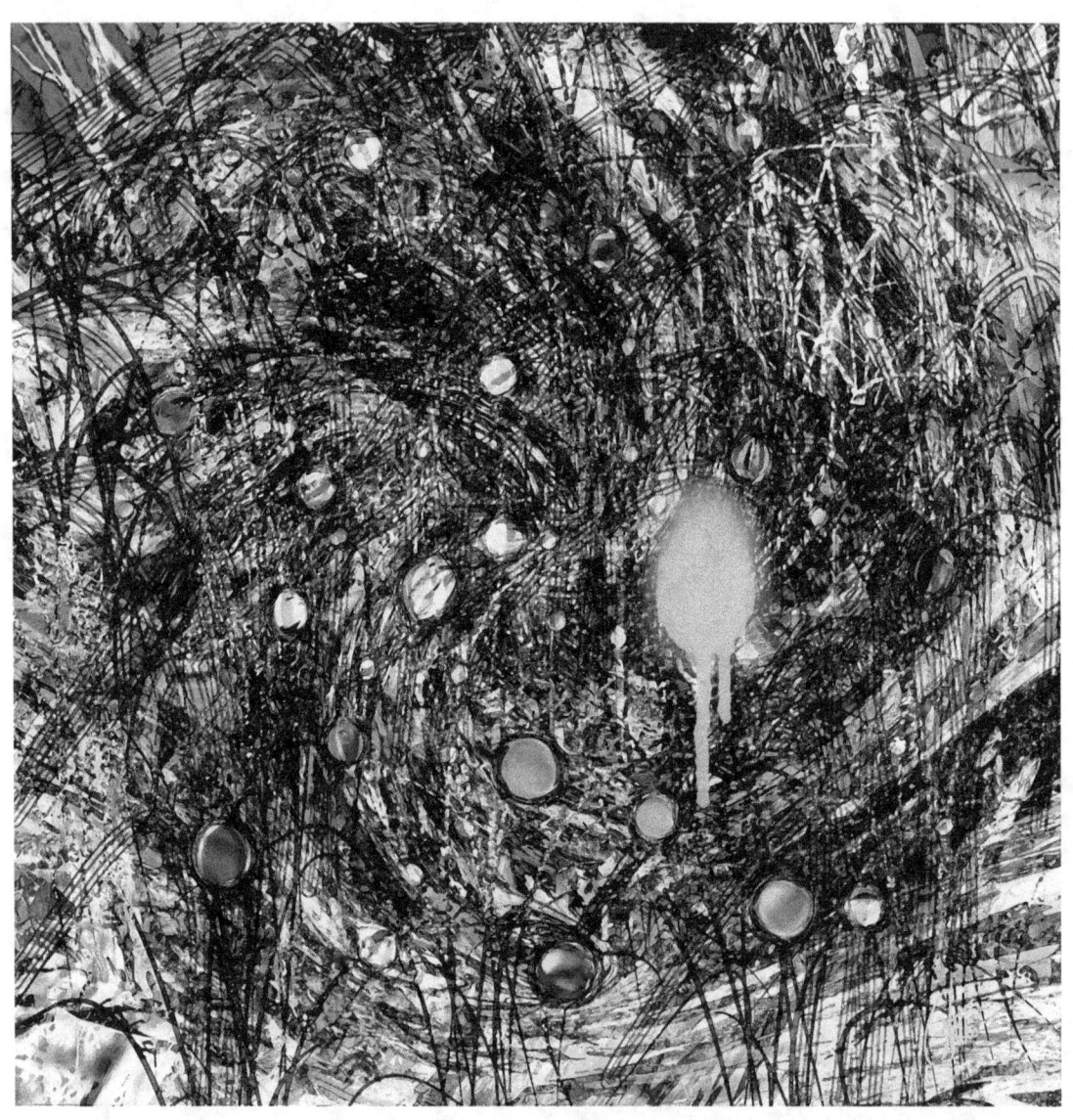

Conspection

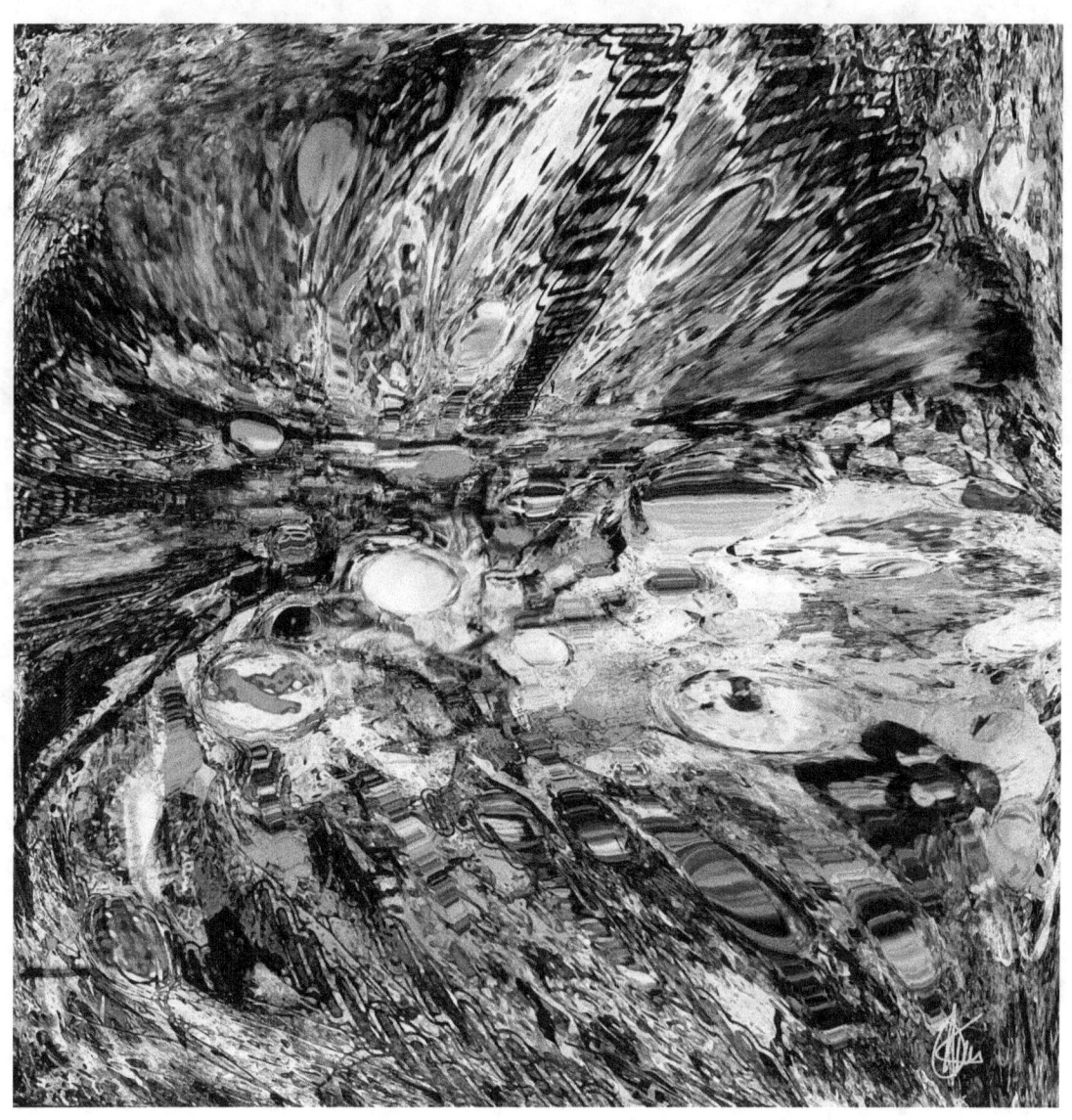

Cosmic Brook

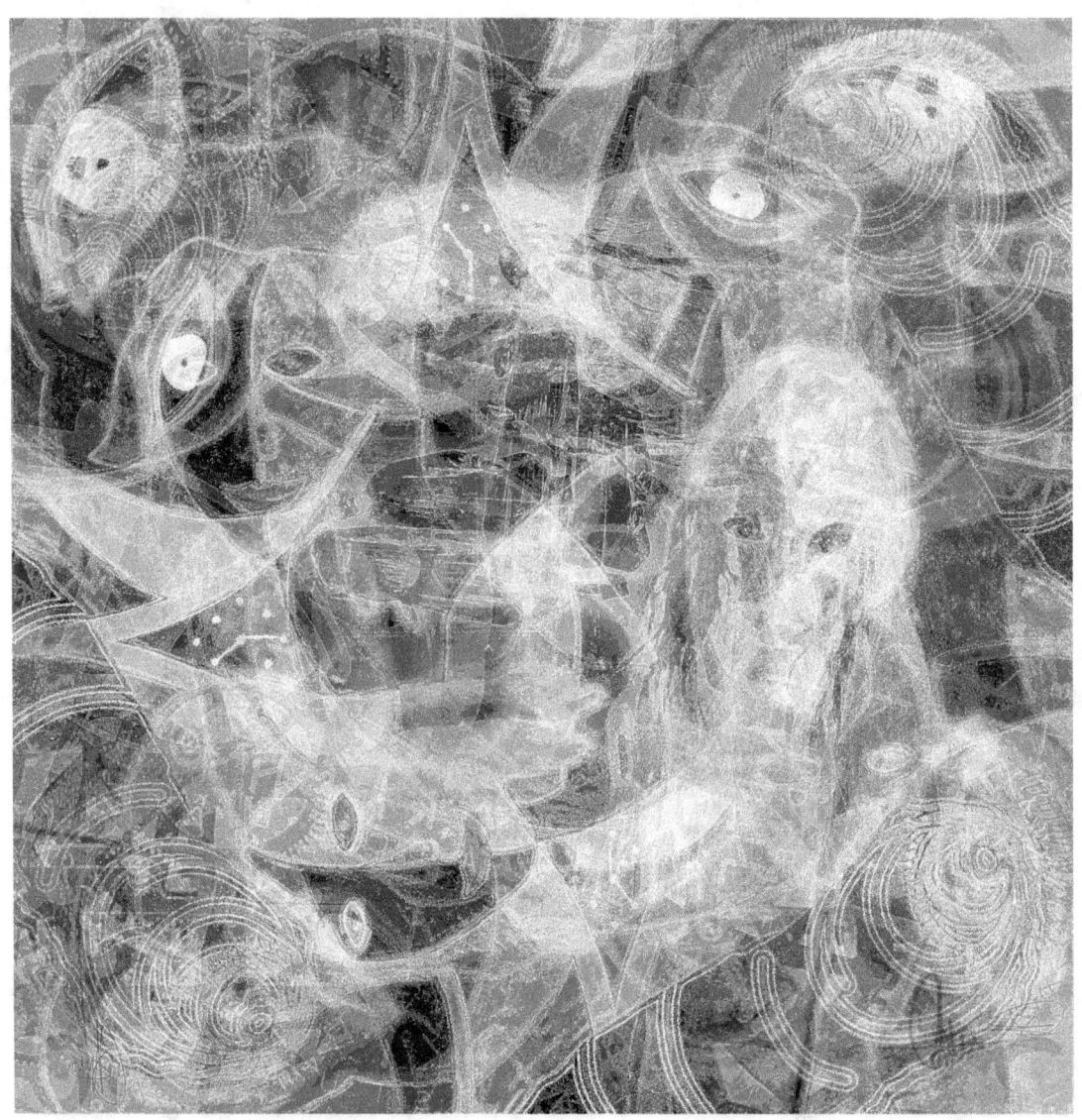

Counselor

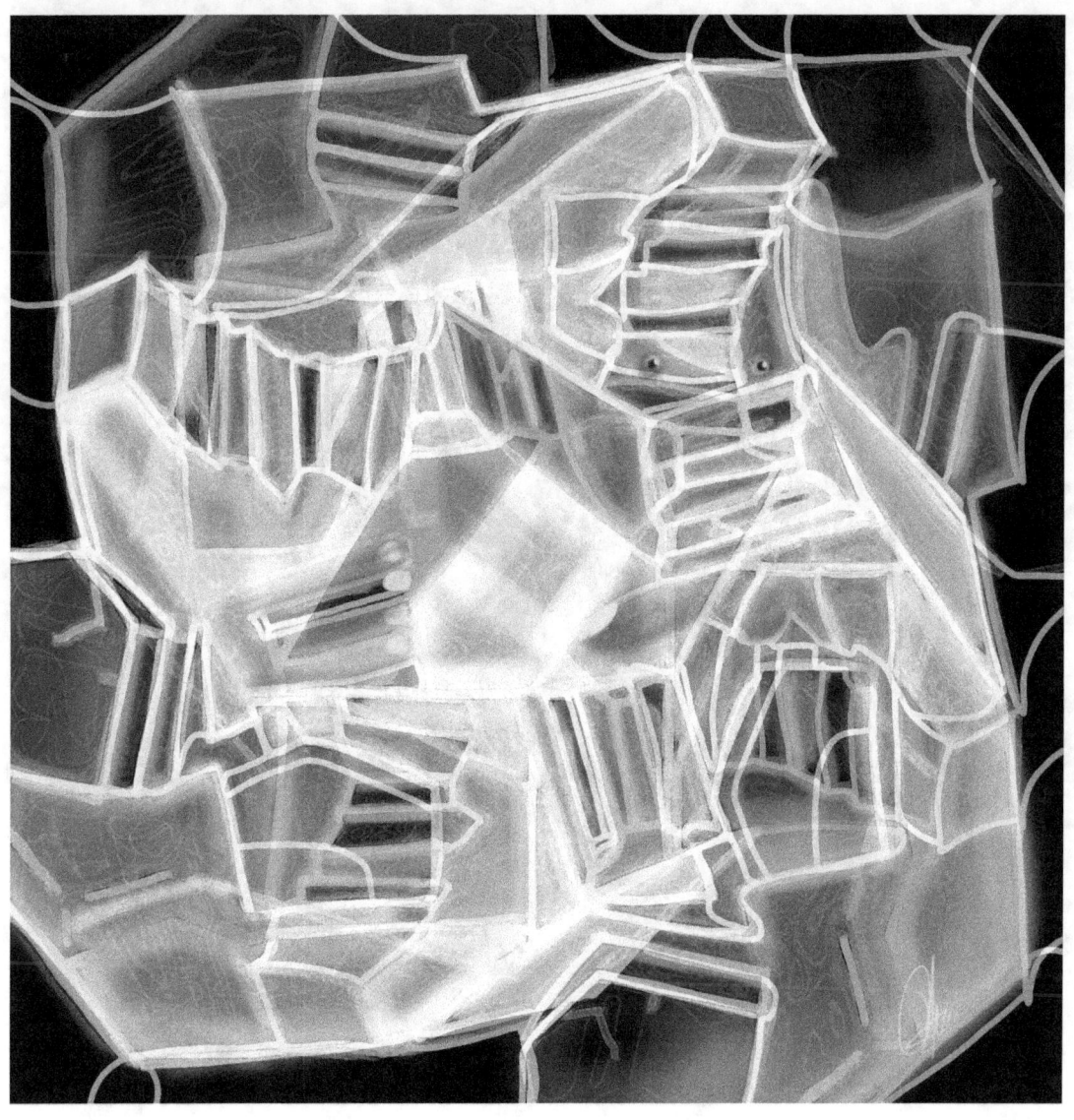

Cubit

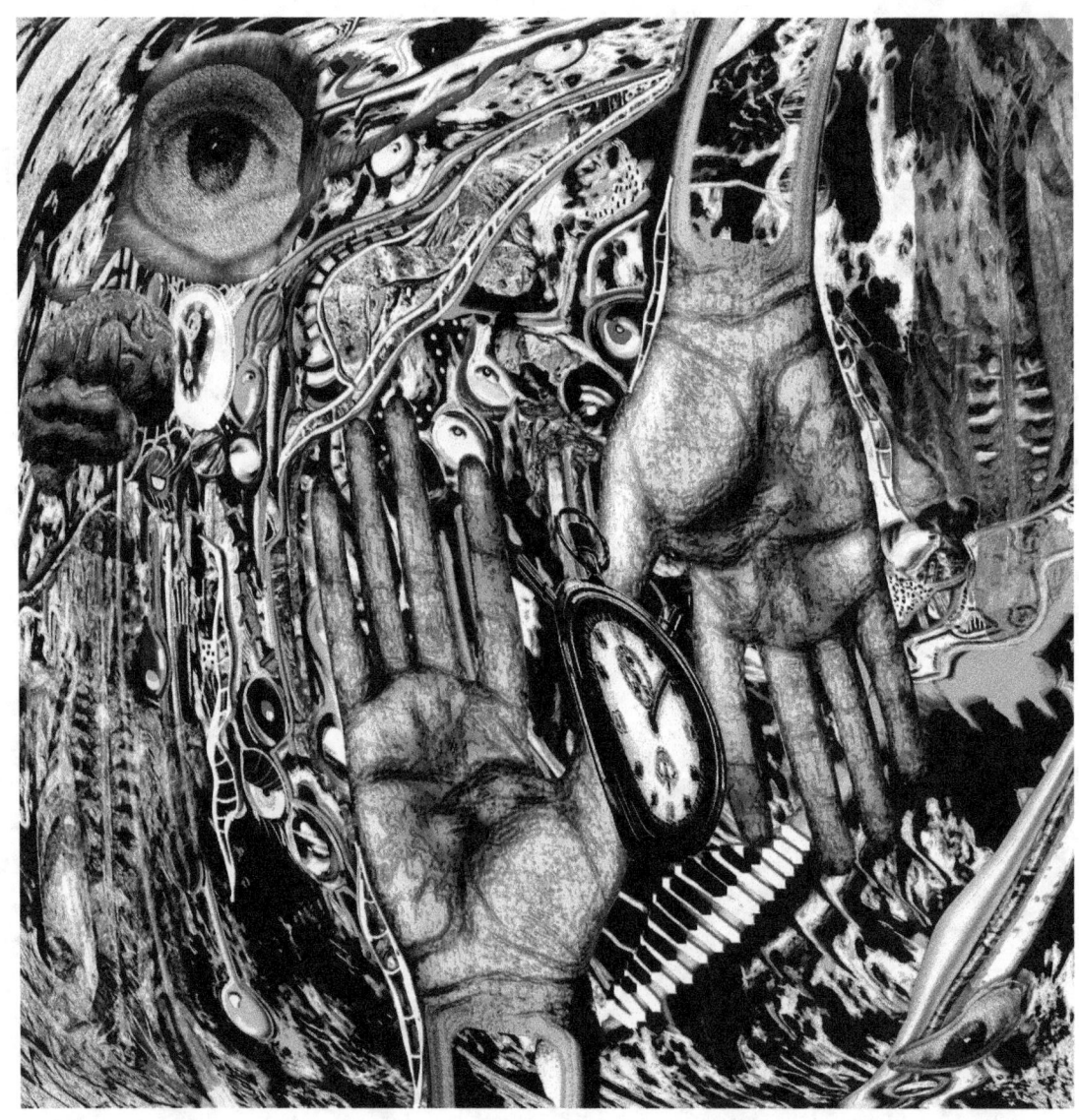

Daito

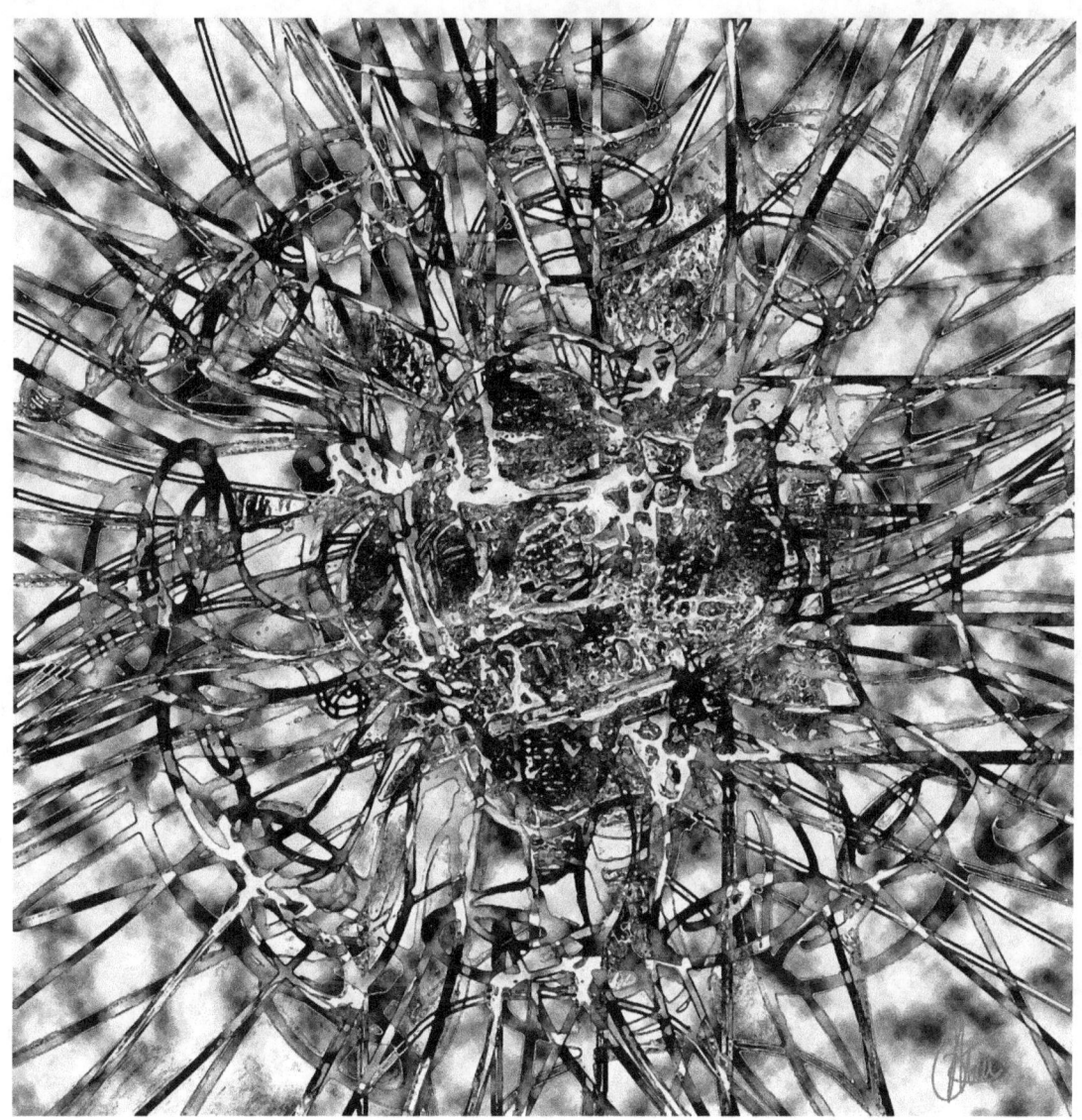

Dendrite

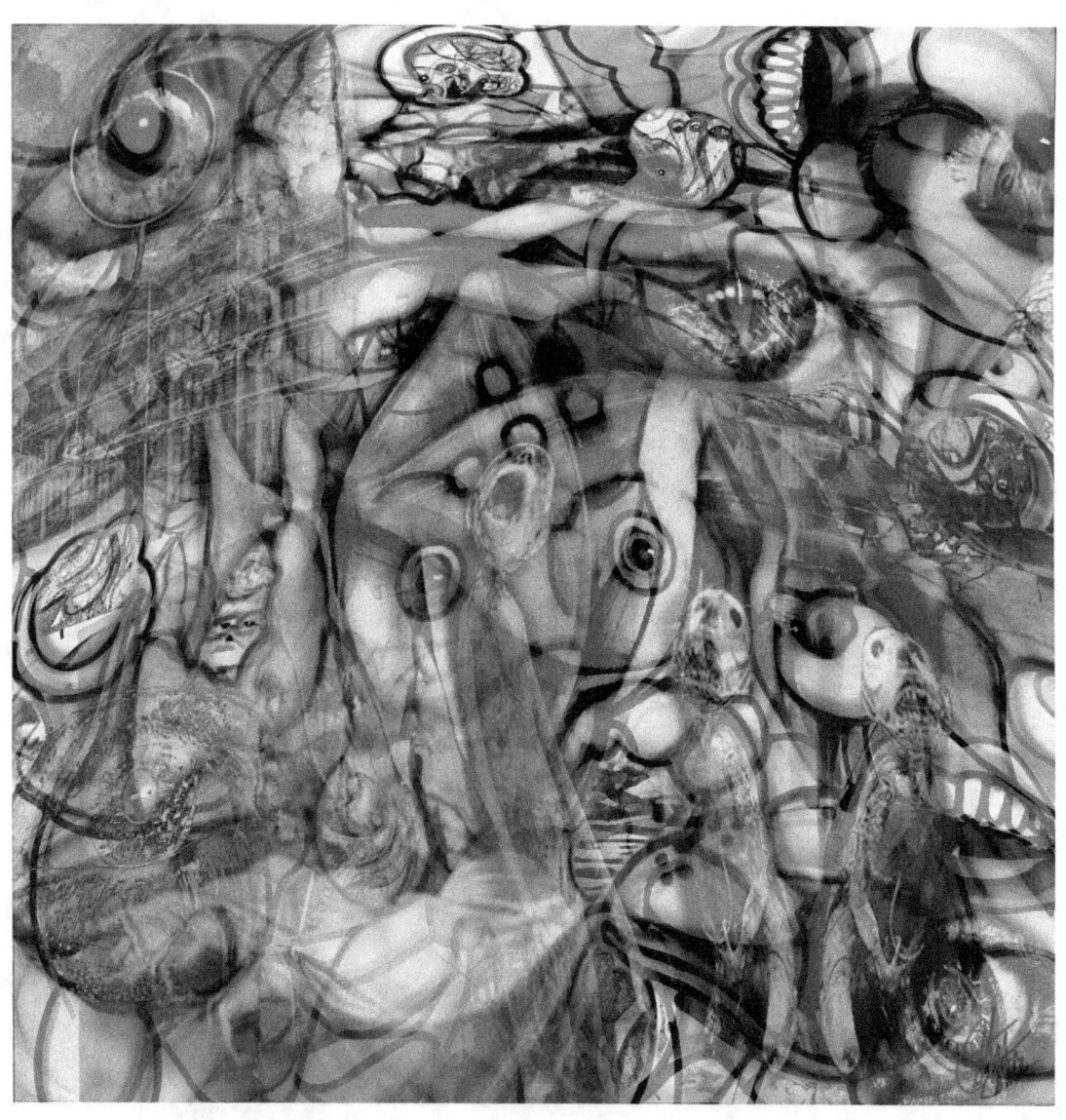

Despair

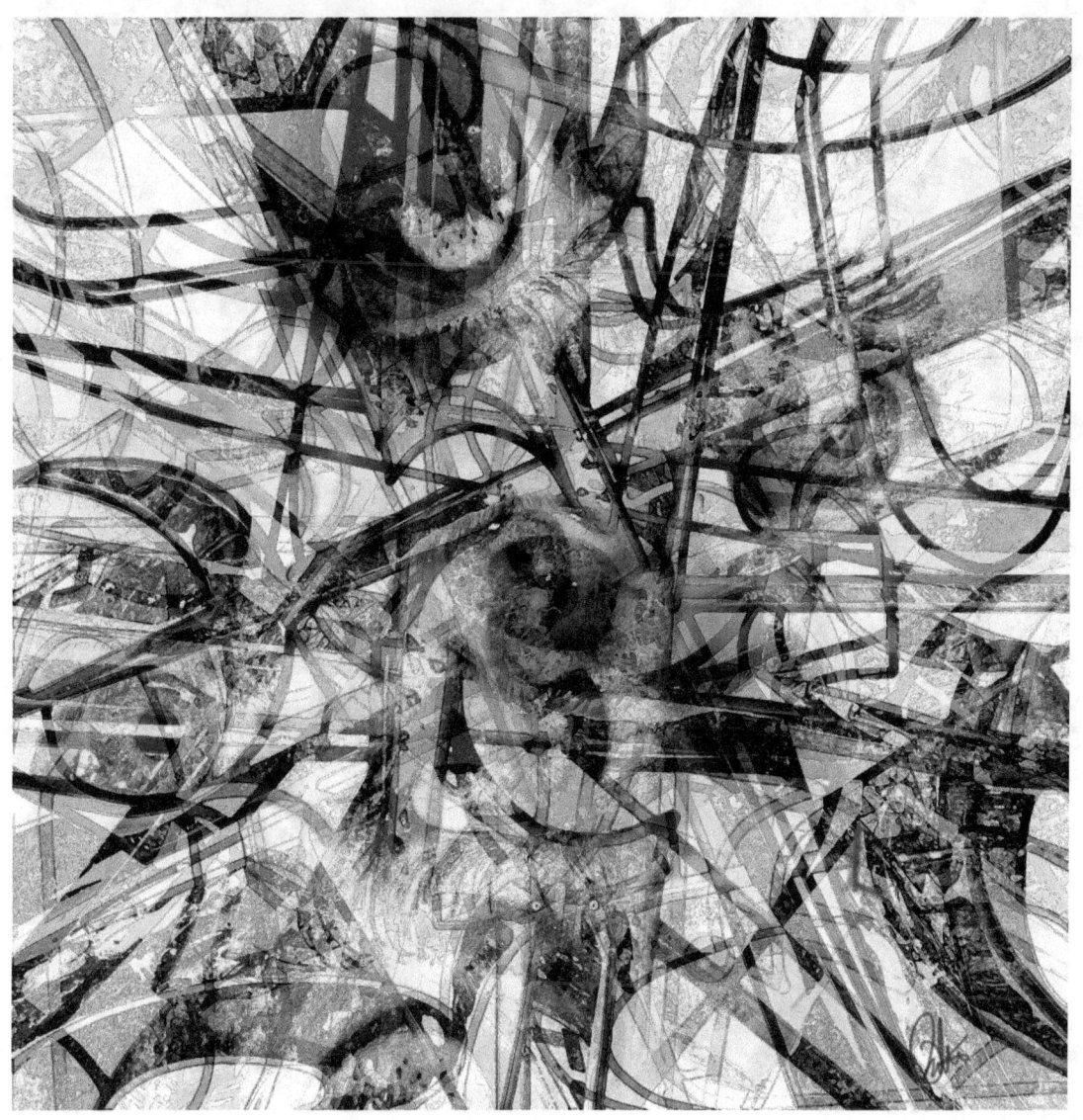

Doggit

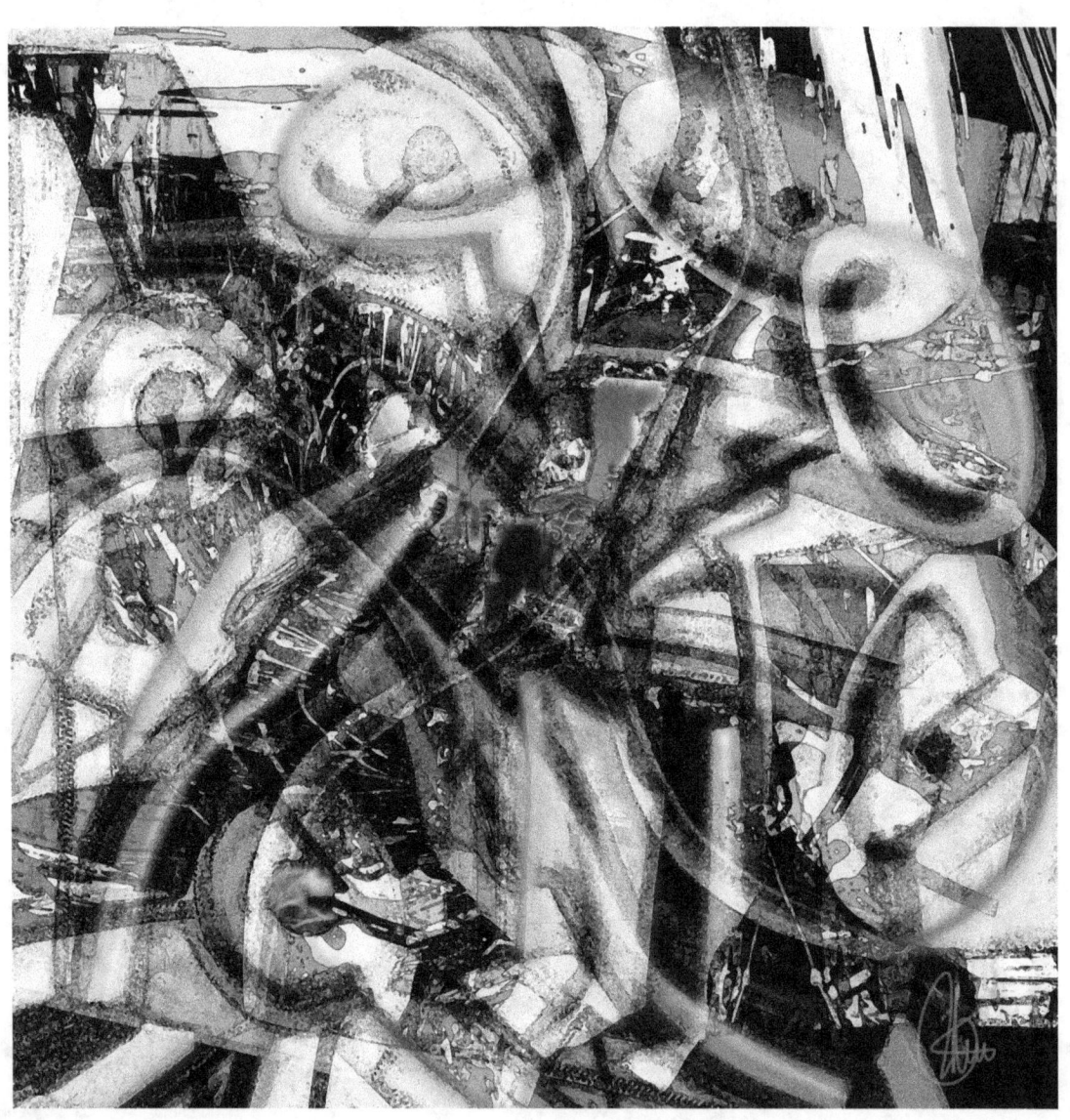

Dongled

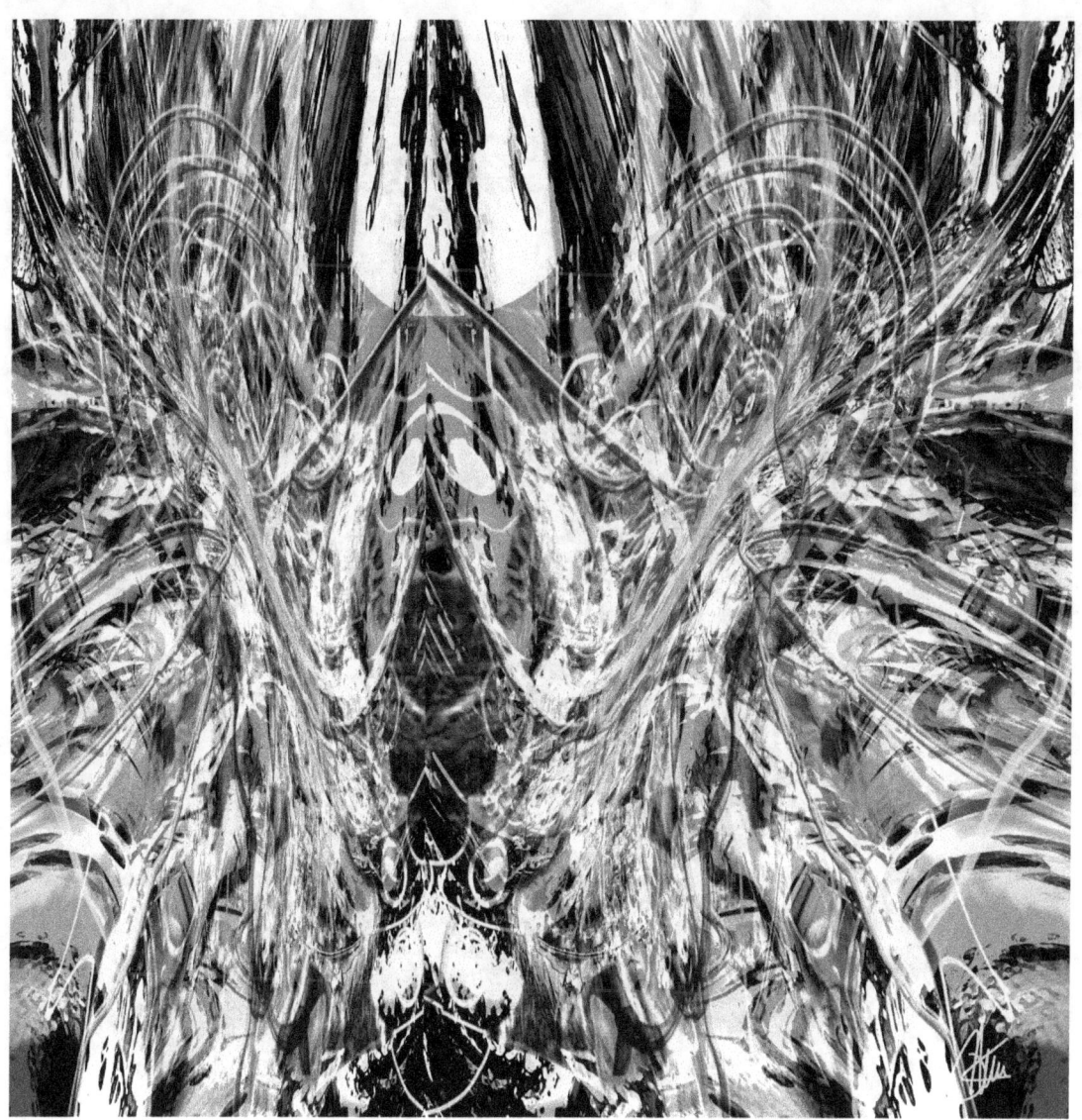

Dowsing

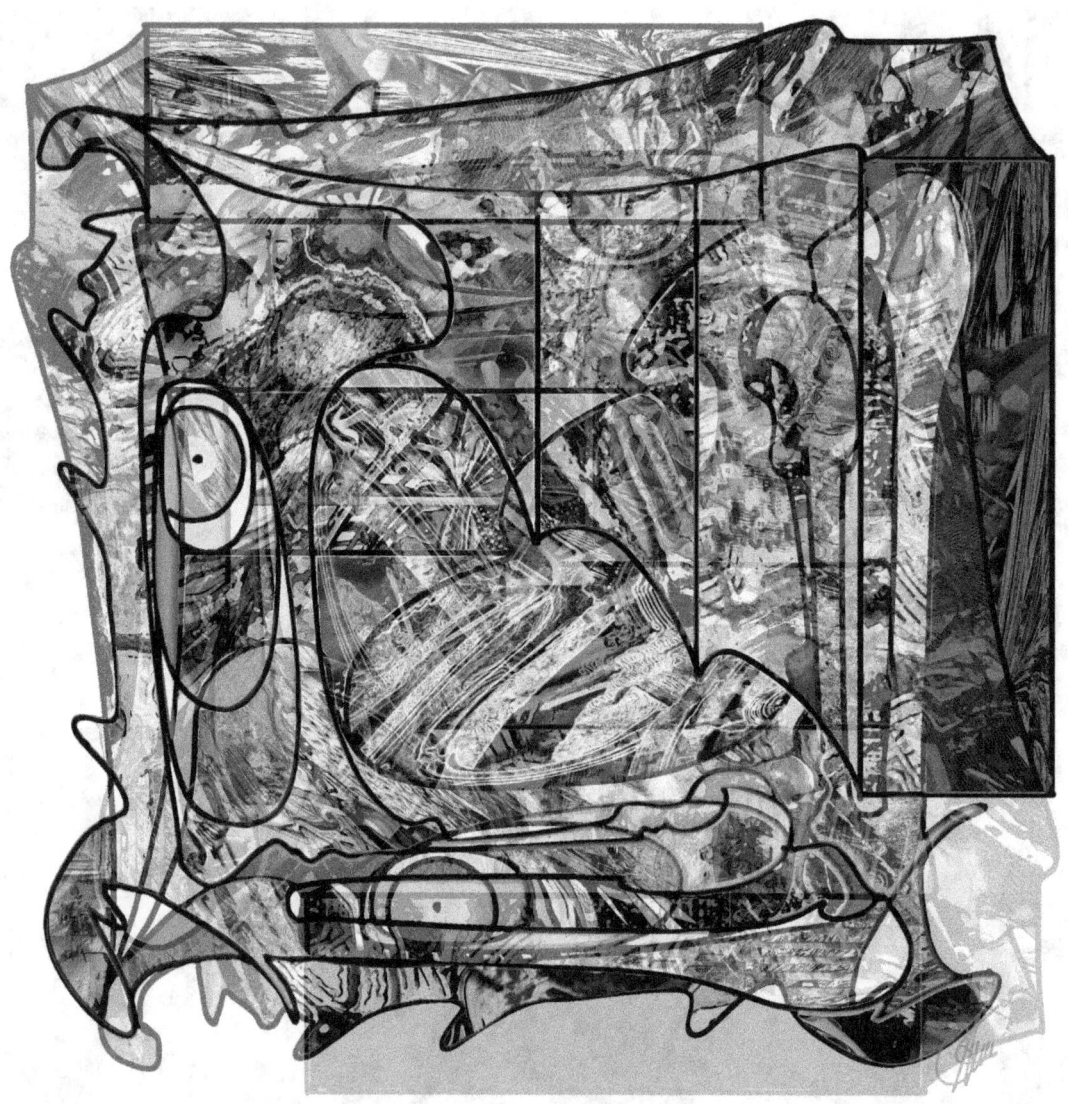

Eagle Over
Shoulder

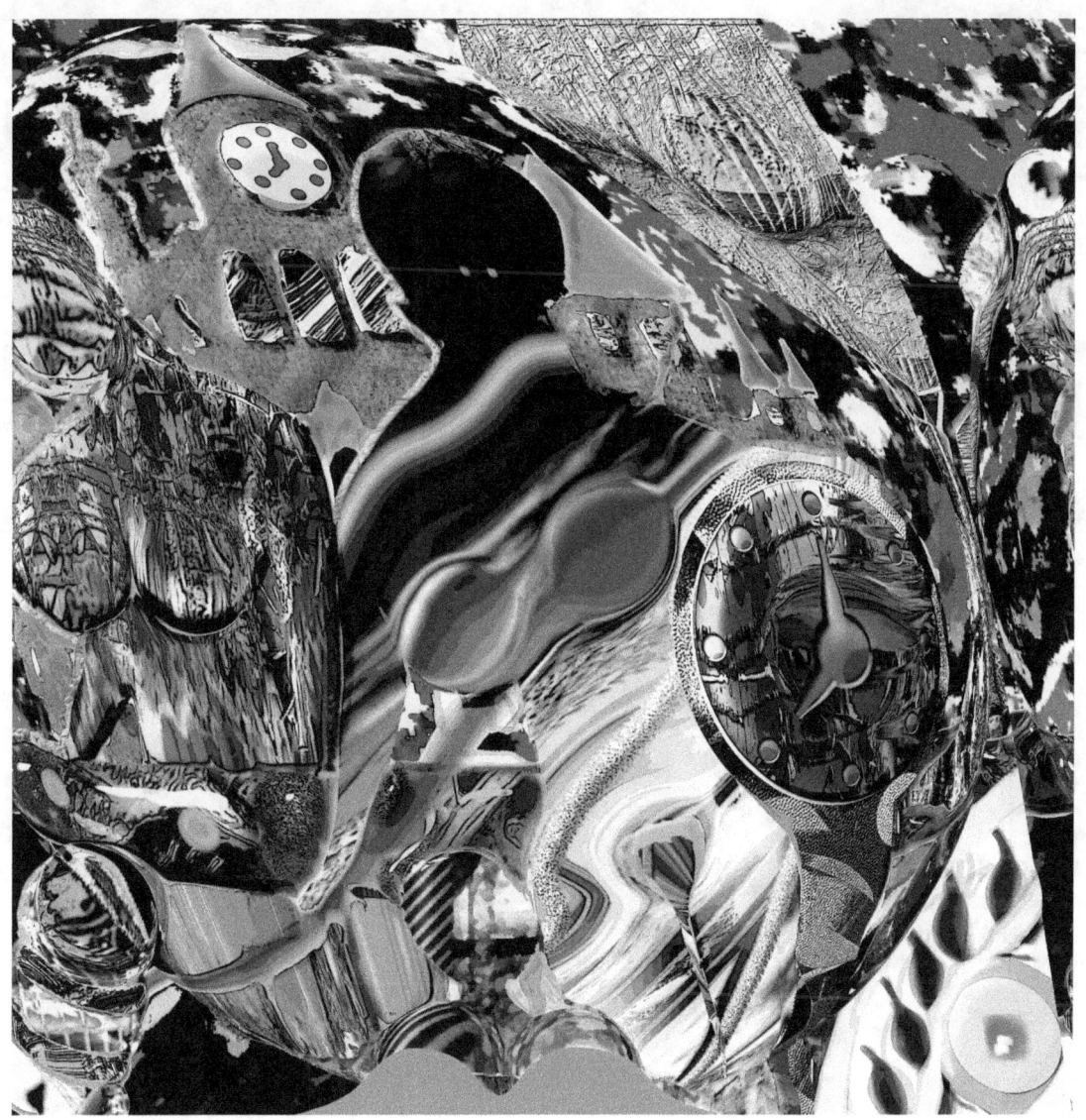

Eight Stages of
Time

Elephant

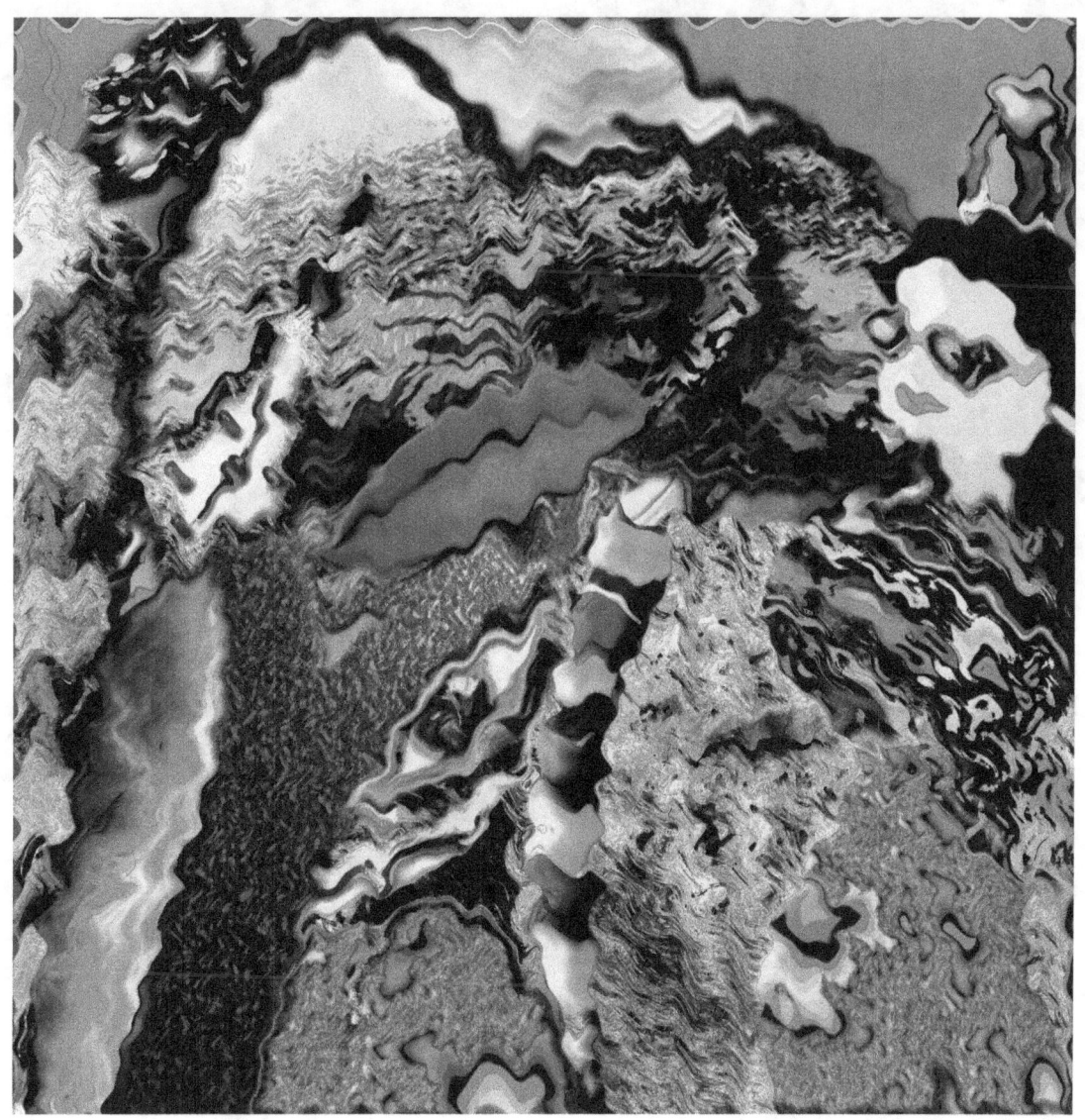

Elipzoid

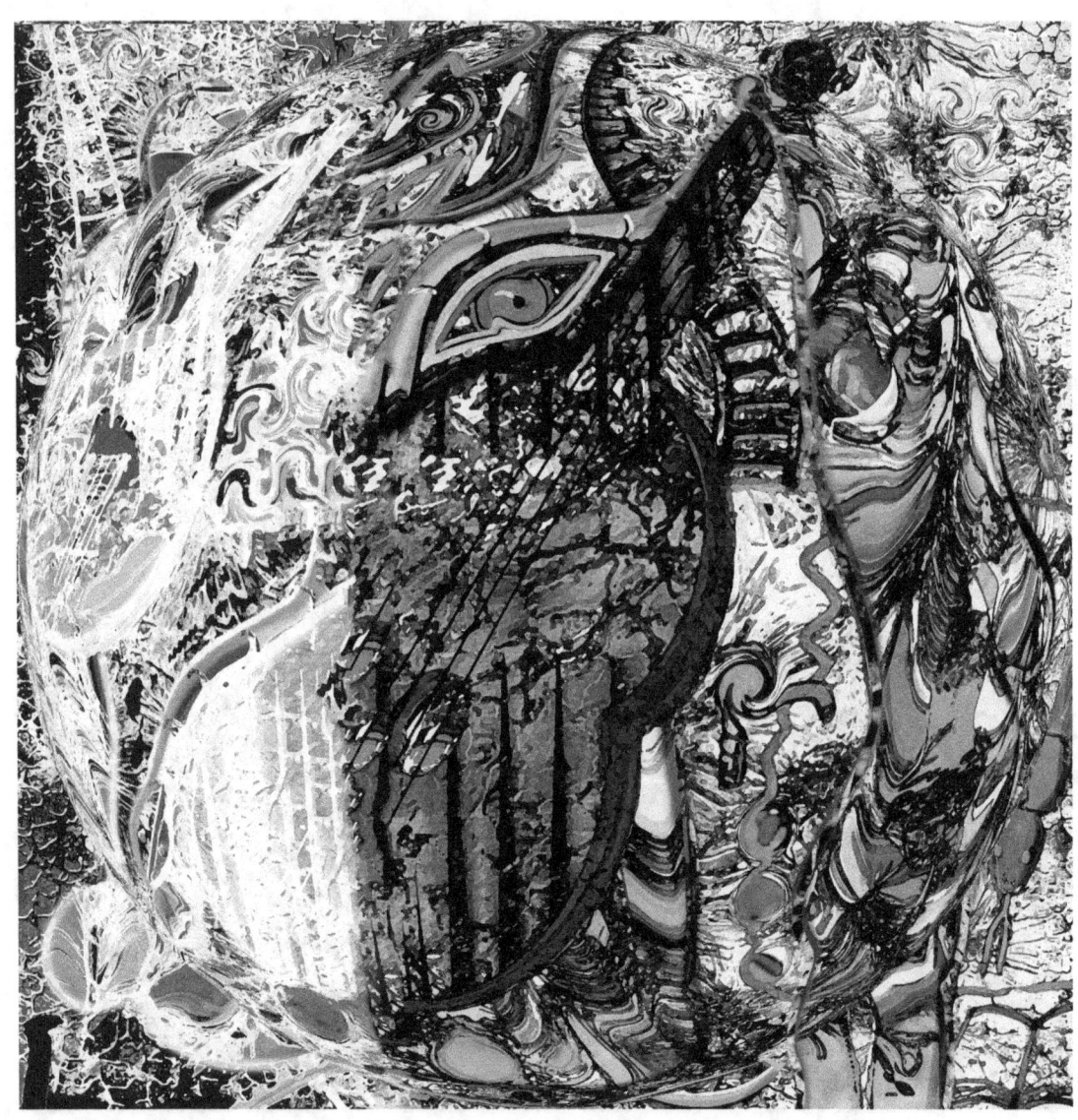

Eye on
Guitar

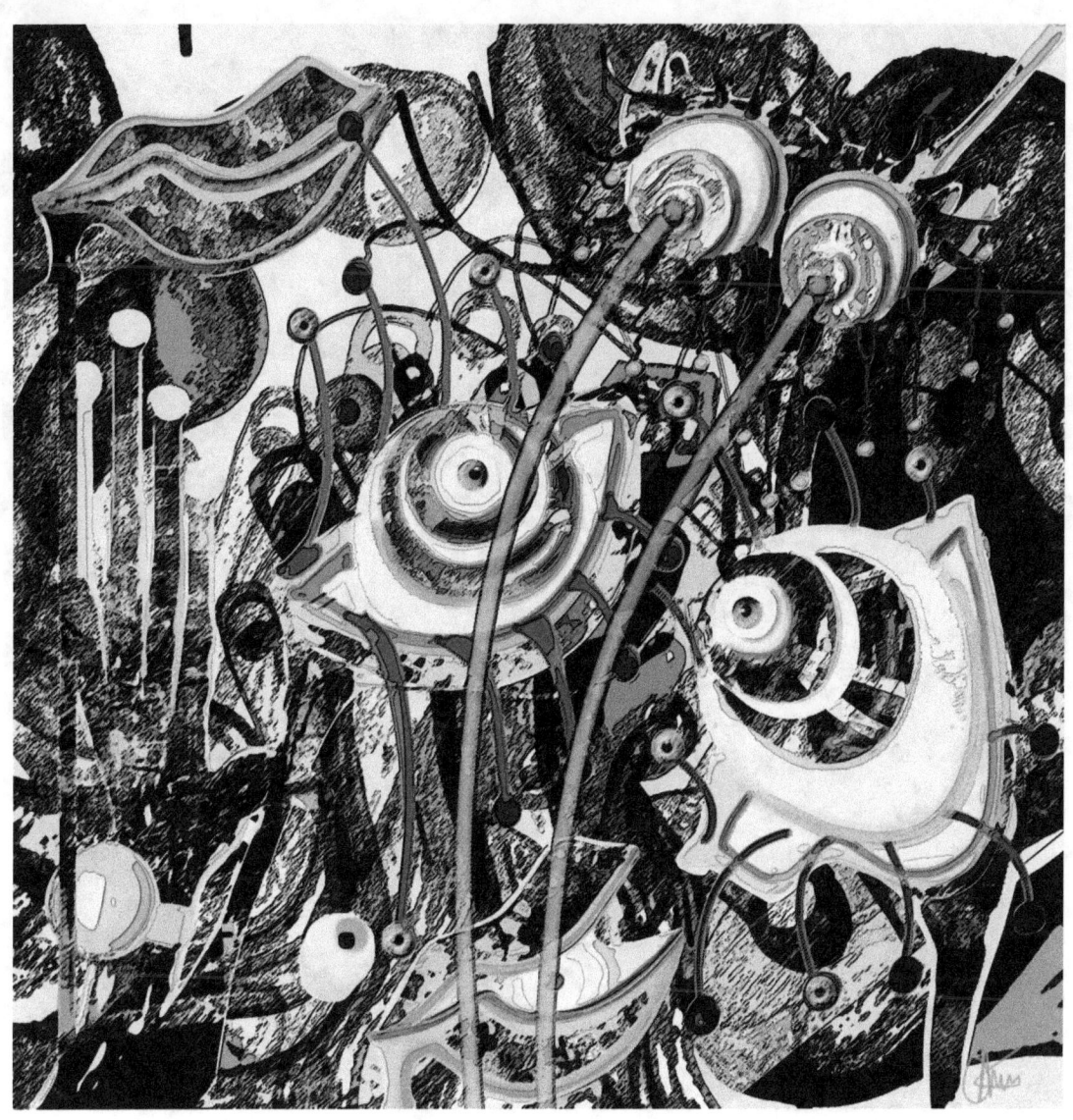

Eye
Sprouts

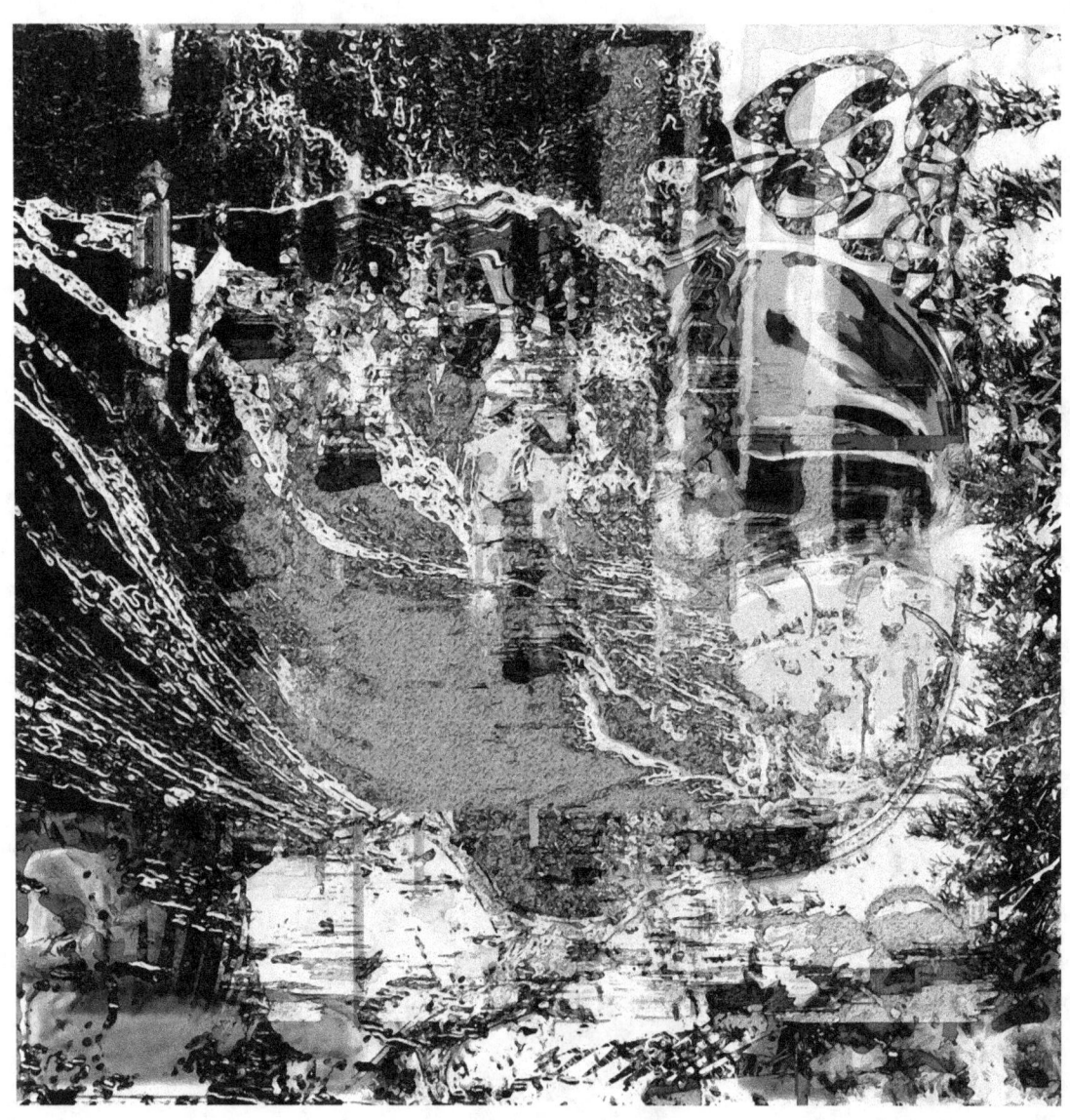

Facadeau

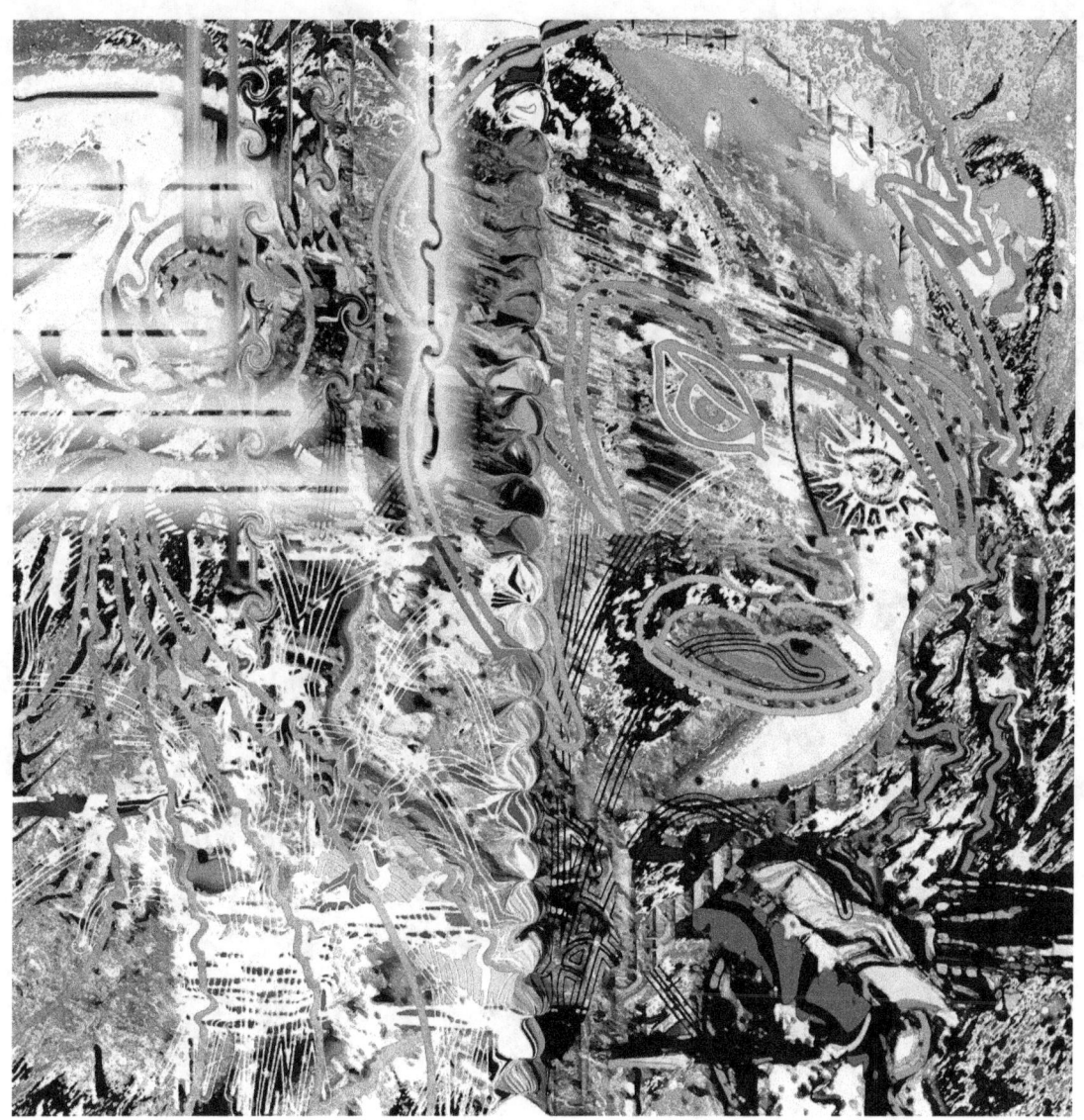

Face in
Panel

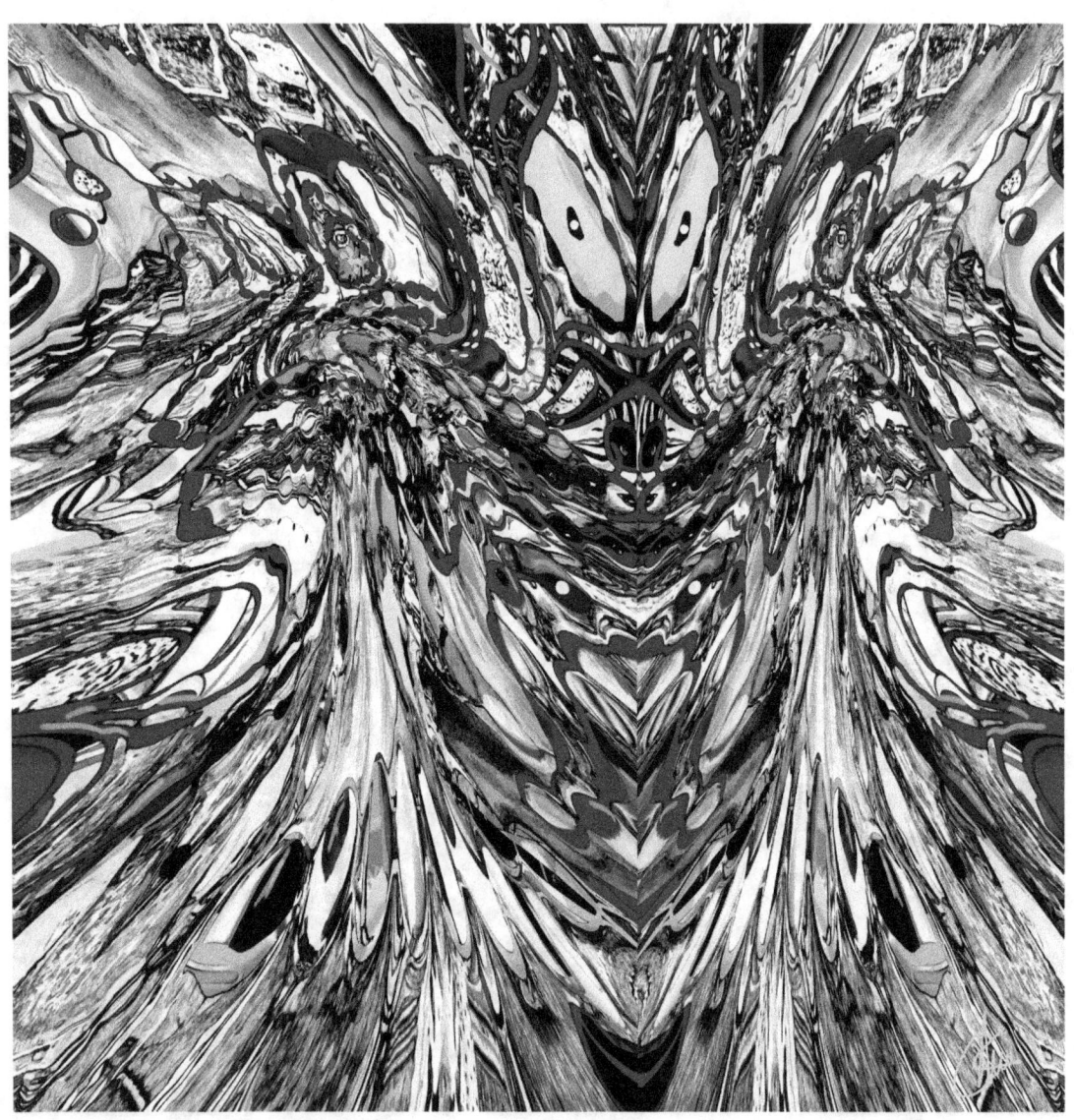

Falconry

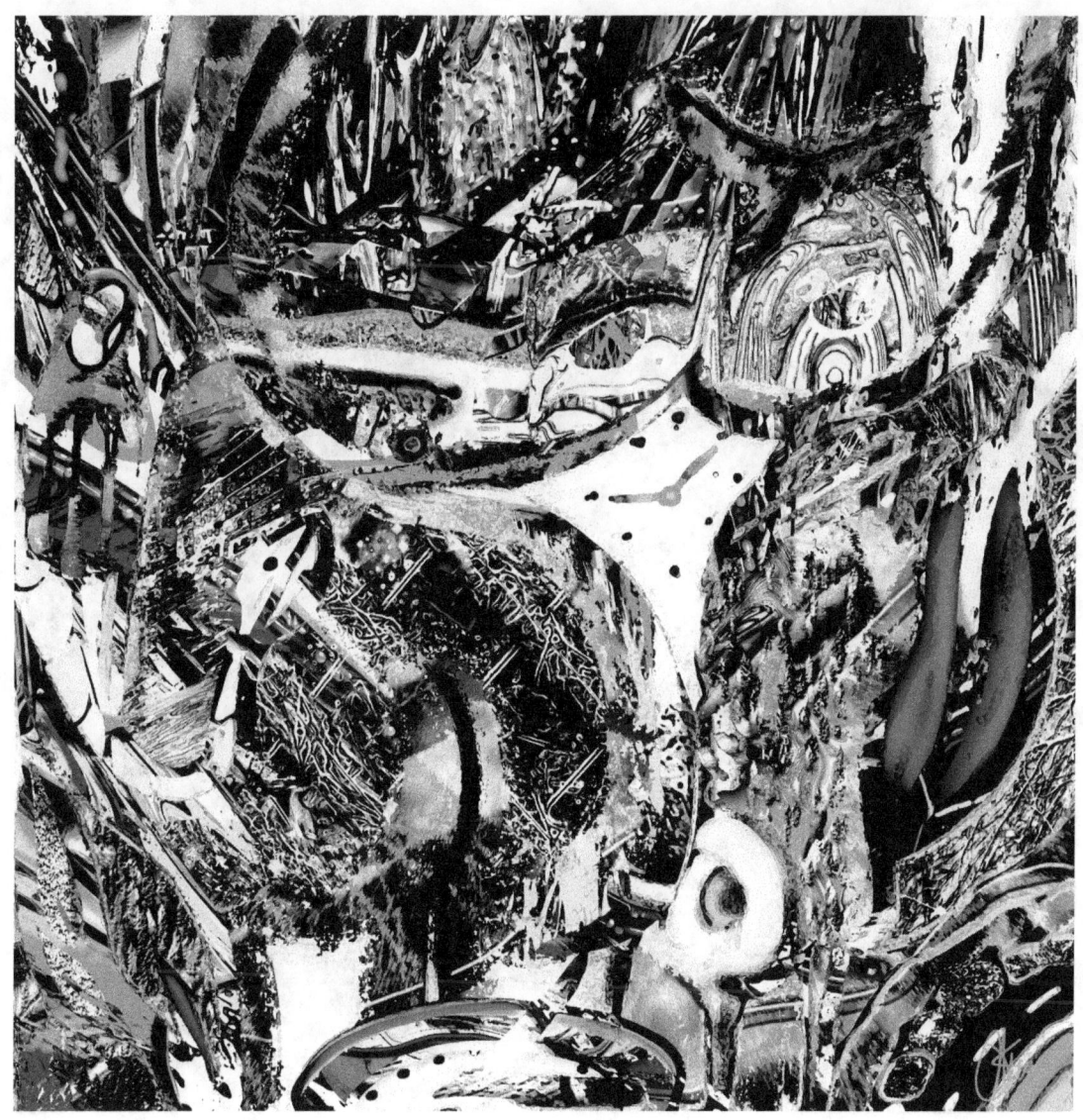

Fanfaro

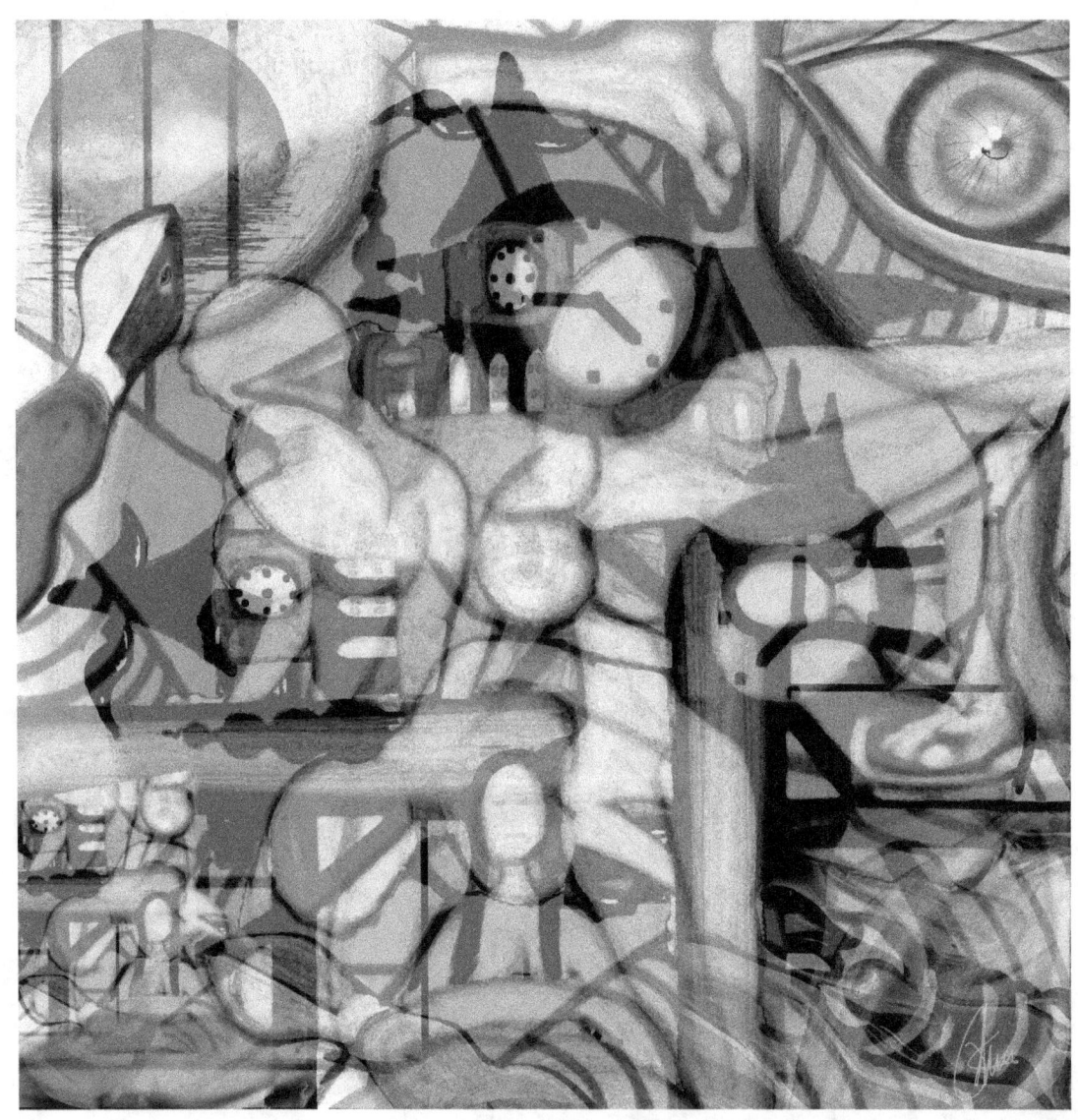

Fate

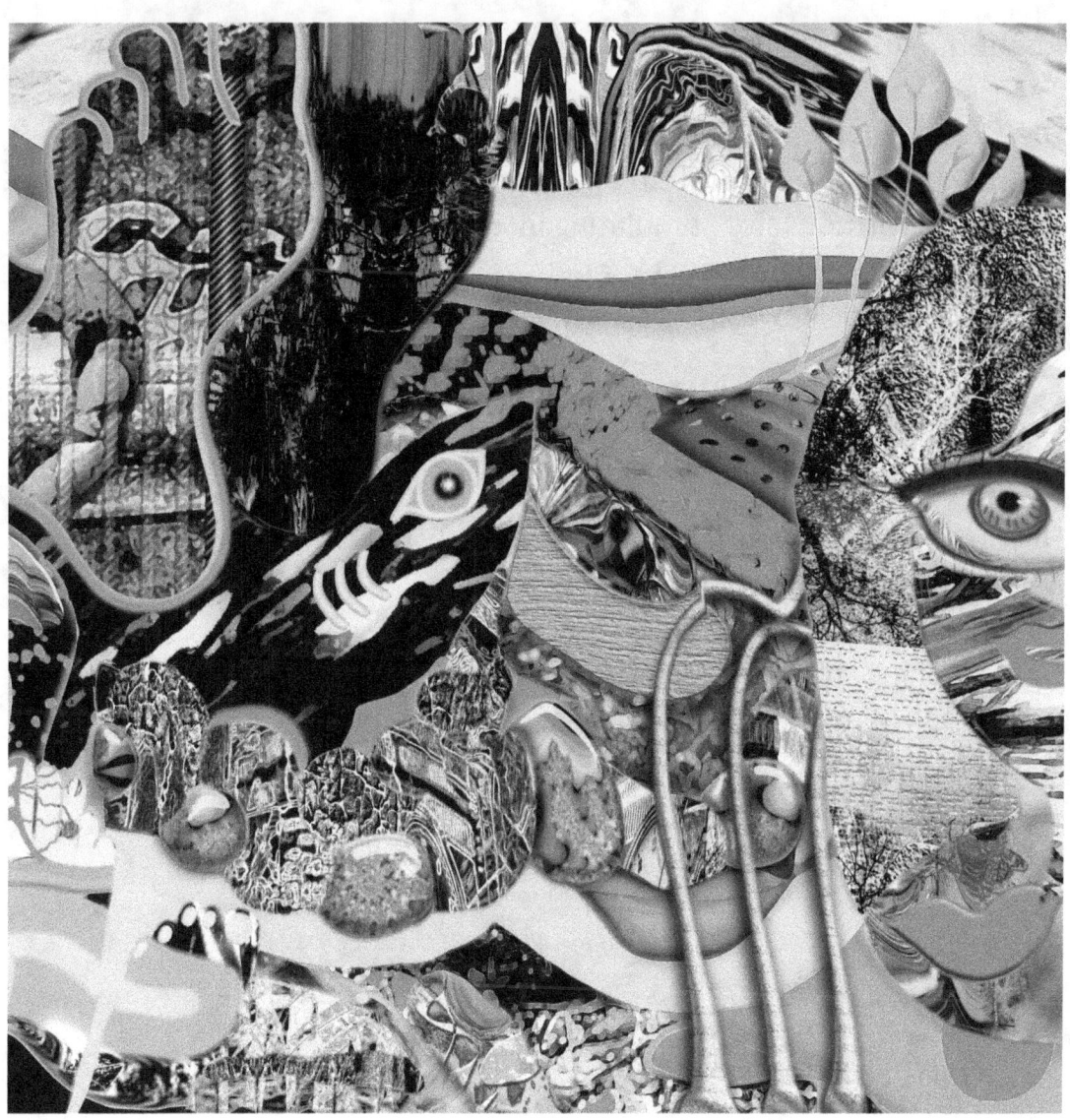

Fish Eye

About the Author

Dr. P. is a cognitive psychologist, writer, and artist. His research involves the reticular activating system and cognitive dissonance arousal. His paintings are known for stimulating incongruity to maximize thought provoking insights and new experiences. Welcome to his mind. Please also consider his newest paperback book releases

Facial Art Reflections ISBN 9781797751108
Abstract facial paintings.

How to Become an Alpha Being ISBN 9781797747774
Self-Help psychology for men and women.

Dante's Children's Colorbook ISBN 9781797754307
Color book of animals for children and adults alike.

www.ingramcontent.com/pod-product-compliance
Lightning Source LLC
Chambersburg PA
CBHW081618220526
45468CB00010B/2936